ANIMATED CARTOONS

ILLUSTRATING THE METHOD OF MAKING ANIMATED
CARTOONS BY CUT-OUTS.

Above: Background scene and the separate items.

Below: Completed scene showing one phase of the performance of the
little cardboard actors and stage property. [*See page* 90]

ANIMATED CARTOONS

HOW THEY ARE MADE
THEIR ORIGIN AND DEVELOPMENT

BY
E.G. LUTZ

ILLUSTRATED

APPLEWOOD BOOKS
BEDFORD, MASSACHUSETTS

Animated Cartoons was first published in 1920
by Charles Scribner's Sons.

Thank you for purchasing an Applewood Book.
Applewood reprints America's lively classics—books
from the past that are of interest to modern readers.
For a free copy of our current catalog, write to:
Applewood Books, P.O. Box 365, Bedford, MA 01730.

ISBN 1-55709-474-8

10 9 8 7 6 5 4 3 2

Library of Congress Cataloging-in-Publication Data
Lutz, Edwin George, b. 1868.
 Animated cartoons: how they are made : their origin
and development / by E.G. Lutz.
 p. cm.
 Originally published: New York: Charles Scribner's Sons,
1920.
 ISBN 1-55709-474-8
 1. Animated films—Technique. I. Title.
NC1765.L8 1998
741.5'8–DC21 97-49496
 CIP

INTRODUCTION

We learn through the functioning of our senses; sight the most precious shows us the appearance of the exterior world. Before the dawn of pictorial presentation, man was visually cognizant only of his immediate or present surroundings. On the development of realistic picturing it was possible, more or less truthfully, to become acquainted with the aspect of things not proximately perceivable. The cogency of the perceptive impression was dependent upon the graphic faithfulness of the agency—a pictorial work—that gave the visual representation of the distant thing.

It is by means of sight, too, that the mind since the beginning of alphabets has been made familiar with the thoughts and the wisdom of the past and put into relationship with the learning and reasoning of the present. These two methods of imparting knowledge—delineatory

and by inscribed symbols—have been concurrent throughout the ages.

It was nearly a century ago that Joseph Nicéphore Niepce (1765–1833), at Châlons-sur-Saône, in France, invented photography. Since that time it has been possible to fix on a surface, by physicochemical means, pictures of the exterior world. It was another way of extending man's horizon, but a way not dependent, in the matter of literalness, upon the variations of any individual's skill or intent, but rather upon the accuracy of material means.

Thoughts and ideas once represented and preserved by picture-writing, recorded by symbolical signs, and at last inscribed by alphabetical marks were, in 1877, registered by mere tracings on a surface and again reproduced by Mr. Edison with his phonograph. As in the photograph, the procedure was purely mechanical, and man's artificial inventions of linear markings and arbitrary symbols were totally disregarded.

Through photography we learn of the exterior nature of absent things and the character of the views in distant places. Or it preserves these

pictorial matters in a material form for the future. The phonograph communicates to us the uttered thoughts of others or brings into our homes the melodies and songs of great artists that we should not otherwise have the opportunity to hear.

And now a new physicochemical marvel has come that apprehends, reproduces, and guards for the future another sensorial stimulus. It is the motion-picture and the stimulus is movement.

Photography and the rendering of sounds by the phonograph have both been adopted for instruction and amusement. The motion-picture also is used for these purposes, but in the main the art has been associated with our leisure hours as a means of diversion or entertainment. During the period of its growth, however, its adaptability to education has never been lost sight of. It is simply that development along this line has not been as seriously considered as it should be. Motion-pictures, it is true, that may be considered as educational are frequently shown in theatres and halls. Such, for instance, are views in strange lands, scenic wonders, and pictures showing the manufacture of some useful article or the manner

of proceeding in some field of human activity. But these are effected entirely by photography and the narration of their making does not come within the scope of this book.

Our concern is the description of the processes of making "animated cartoons," or moving screen drawings. Related matters, of course, including the inception and the development of motion-pictures in general, will be referred to in our work. At present, of the two divisions of our subject, the art of the animated comic cartoon has been most developed. It is for this reason that so much of the book is given to an account of their production.

But on the making of animated screen drawings for scientific and educational themes little has been said. This is not to be taken as a measure of their importance.

It is interesting to regard for a moment the vicissitudes of the word cartoon. Etymologically it is related to words in certain Latin tongues for paper, card, or pasteboard. Its best-accepted employment—of bygone times—was that of designating an artist's working-size preliminary

draft of a painting, a mural decoration, or a design for tapestry. Raphael's cartoons in the South Kensington Museum, in London, are the best-known works of art coming under this meaning of the term. (They are, too, the usual instances given in dictionaries when this meaning is explained.) The most frequent use of the word up to recently, however, has been to specify a printed picture in which the composition bears upon some current event or political topic and in which notabilities of the day are generally caricatured. The word cartoon did not long particularize this kind of pictorial work but was soon applied to any humorous or satirical printed picture no matter whether the subject was on a topic of the day or not.

When some of the comic graphic artists began to turn their attention to the making of drawings for animated screen pictures, nothing seemed more natural than that the word "animated" should be prefixed to the term describing their products and so bringing into usage the expression "animated cartoons." But the term did not long remain restricted to this application, as

it soon was called into service by the workers in
the industry to describe any film made from
drawings without regard to whether the subject
was of a humorous or of an educational char-
acter. Its use in this sense is perhaps justified
as it forms a convenient designation in the trade
to distinguish between films made from drawings
and those having as their basic elements actuality,
that is, people, scenes, and objects.

Teachers now are talking of "visual instruc-
tion." They mean by this phrase in the special
sense that they have given to it the use of motion-
picture films for instructional purposes. Travel
pictures to be used in connection with teaching
geography or micro-cinematographic films for
classes in biology are good examples of such films.
But not all educational subjects can be depicted
by the camera solely. For many themes the
artist must be called in to prepare a series of draw-
ings made in a certain way and then photographed
and completed to form a film of moving diagrams
or drawings.

As it is readily understood that any school
topic presented in animated pictures will stim-

ulate and hold the attention, and that the proper-
ties of things when depicted in action are more
quickly grasped visually than by description or
through motionless diagrams, it is likely that visual
instruction by films will soon play an important
part in any course of studies. Then the motion-
picture projector will become the pre-eminent
school apparatus and such subjects as do not
lend themselves to photography will very generally
need to be drawn; thereupon the preponderance of
the comic cartoon will cease and the animated
screen drawing of serious and worth-while themes
will prevail.

E. G. L.

CONTENTS

ILLUSTRATIONS

Illustrations

Illustrations xix

THE BEGINNING OF ANIMATED
DRAWINGS

CHAPTER I

THE BEGINNING OF ANIMATED DRAWINGS

THE picture thrown on the wall by the magic-lantern, although an illusion, and no more tangible than a shadow, has nevertheless a certain tactile quality. If it is projected from a drawing on a glass slide, its design is definite; and if from a photographic slide, the tones are clearly discernible. It is—unless it is one of those quaintly moving amusing subjects operated by a crude mechanism—a quiescent picture. The spirited screen picture thrown by the lens of a motion-picture projector is an illusion, too. It exemplifies, however, two varieties of this class of sensory deceptions. First: it is an illusion for the same reason that the image from the magic-lantern is one; namely, a projected shadow of a more or less opaque design on a transparent material intervening between the illuminant and the lens. And secondly, it is an illusion in that it synthesizes mere pictorial spectres into the appearance of life and movement. This latter particular, the seem-

ing activity of life, is the fundamental dissimilarity between pictures projected by the magic-lantern and those thrown on the screen by the motion-picture apparatus.

And it is only the addition to the magic-lantern, of a mechanism that makes possible this optical vibration of life and motion, that constitutes the differing feature in the two types of projecting machines.

In the magic-lantern and its improved form, the stereopticon, separate views of different subjects are shown in succession. Each picture is allowed to remain on the screen long enough to be readily beheld and appreciated. But the picture is at rest and does not move. With the motion-picture projector a series of slightly varying pictures of the same subject are projected in quick succession. This succession is at such a rapid rate that the interval of time during which one picture moves out of place to make way for the next is so short that it is nearly imperceptible. In consequence, the slightly varying pictures blend on the screen and we have a phantasmagoria of movement.

The phenomenon of this movement—this sem-

blance to life—takes place, not on the screen, but within the eye. Its consideration, a subject proper for the science of physiology (and in some aspects psychology), has weight for us more particularly as a matter of physics.

Memory has been said to be an attribute of all organic matter. An instance of this seems to be the property of the eye to retain on its retina an after-image of anything just seen. That is to say, when an object impresses its image upon the retina and then moves away, or disappears, there still remains, for a measurable period, an image of this object within the eye. This singularity of the visual sense is spoken of as the persistence of vision or the formation of positive after-images. And it is referred to as a positive after-image in contradistinction to another visional phenomenon called the negative after-image. This latter kind is instanced in the well-known experiment of fixing the eyes for a few moments upon some design in a brilliant color and quickly turning away to gaze at a blank space of white where instantly the same design will be seen, but of a color complementary to that of the particular hue first gazed at.

The art of the motion-picture began when physicists first noticed this peculiarity of the organ of sight in retaining after-images. The whole art is based on its verity. It is the special quality of the visual sense that makes possible the appreciation of living screen pictures.

An interesting matter to bear in mind is the circumstance that the first attempt at giving to a screen image the effect of life was by means of a progressive series of drawings. When photographs came later, drawings were forgotten and only when the cinematographic art had reached its great development and universality, were drawings again brought into use to be synthesized on the screen.

To describe how these drawings are made, their use and application to the making of animated cartoons, is the purpose of this book.

Before proceeding with a sketch of the development of the art of making these cartoons, it will make the matter more readily understood if we give, at first, in a few paragraphs, a brief description of the present-day method of throwing a living picture on the screen by the motion-picture projector.

The projector for motion-pictures, like the magic-lantern, consists of an illuminant, reflector, condenser, and objective. This last part is the combination of lenses that gather and focus the

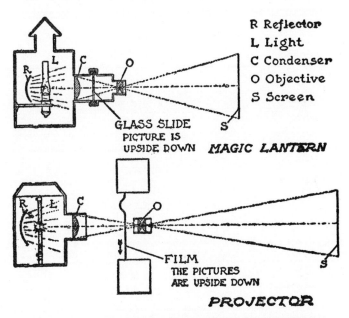

R Reflector
L Light
C Condenser
O Objective
S Screen

GLASS SLIDE
PICTURE IS
UPSIDE DOWN *MAGIC LANTERN*

FILM
THE PICTURES
ARE UPSIDE DOWN

PROJECTOR

MAGIC-LANTERN AND MOTION-PICTURE PROJECTOR
COMPARED.

light rays carrying the pencils of lights and shadows composing the picture and throwing them on the screen. There is, in the magic-lantern, immediately back of the objective, a narrow aper-

ture through which the glass slide holding a picture
is thrust. In the motion-picture apparatus, the
transparent surface containing the picture also
passes back of the objective, but instead of the
simple process of pushing one slide through to
make way for another, there is a complicated
mechanism to move a long ribbon containing
the sequence of pictures that produces the image
on the screen. Now this ribbon consists of a strip
of transparent celluloid * divided into a series of
little rectangular spaces each with a separate
photograph of some one general scene but each
with slight changes in the moving details—ob-
jects or figures. These changes record the move-
ments from the beginning to the end of the par-
ticular story, action, or pantomime.

Along the edges of the ribbons are rows of
perforations that are most accurately equalized
with respect to their size and of the distances
between them. It is by means of wheels with
teeth that engage with the perforations and the
movement of another toothed part of the mecha-

* Celluloid is at this date the most serviceable material for these
ribbons. But as it is inflammable a substitute is sought—one that has
the advantages possessed by celluloid but of a non-combustible
material.

nism that the ribbon or film is carried across the path of light in the projecting machine. The device for moving the film, although not of a very intricate character, is nevertheless of an ingenious type. It is intermittent in action and operates so that one section of film, containing a picture, is held in the path of light for a fraction of a second, moved away and another section, with the next picture, brought into place to be projected in its turn. This way of working, in most of the projectors, is obtained by the use of a mechanical construction known as the Geneva movement. The pattern of its principal part is a wheel shaped somewhat like a Maltese cross. The form shown in the illustration is given as a type; not all are of this pattern, nor are they all four-parted.

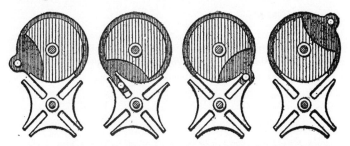

FOUR PHASES OF THE ACTION OF THE INTERMITTENT GEARING KNOWN AS THE GENEVA MOVEMENT.

It is obvious that while one picture moves out of the way for the next, there would be a blur on the screen during such a movement if some means were not devised to prevent it. This is found by eclipsing the light during the time of the change from one picture to another. The detail of the projector that effects this is a revolving shutter with a solid part and an open section. (This is the old type of shutter. It is noticed here because the way in which the light rays project the picture is easily explained by using it as an example.) This shutter is so geared with the rest of the mechanism that (1) the solid part passes across the path of light while another picture is moving into place; and that (2) the open section passes across the path of light while a rectangular area containing a picture is at rest and its details are being projected on the screen.

It may be asked, at this point, why the eye is not aware on the screen of the passing shadow of the opaque part of the shutter as it eclipses the light. It would seem that there should be either a blur or a darkened period on the screen. But the mechanism moves so rapidly that the passing of the solid portion of the shutter is not ordinarily perceptible.

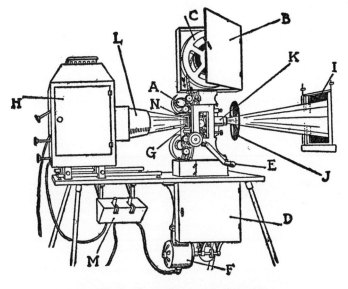

A MOTION-PICTURE PROJECTOR.

A. Film. *B.* Upper magazine. *C.* Feed reel. *D.* Lower magazine, containing the take-up reel. *E.* Crank to operate mechanism by hand. *F.* Motor. *G.* Where the film stops intermittently to be projected. *H.* Lamp-house. *I.* Port, or window in the fireproof projection booth. *J.* Rotating shutter. *K.* Lens. *L.* Condenser. *M.* Switches. *N.* Fire shutter; automatically drops when the film stops or goes too slowly.

One foot of celluloid film contains sixteen separate pictures, and these pass in front of the light in one second. One single tiny picture of the film takes up then one-sixteenth of a second. But not all of this fraction of a second is given to the projection of the picture as some of the time is taken up with moving it into place immediately before projection. The relative apportionment

of this period of one-sixteenth of a second is so arranged that about five-sixths of it (five ninety-sixths of a second) is given to the holding of the film at rest and the projection of its picture, and the remaining one-sixth (one ninety-sixth of a second) is given to the movement of a section of the film and the shutting off of the light by the opaque part of the shutter.

In the last few paragraphs we have referred to the old type of shutter which caused a flicker, or unsteadiness of light on the screen. Nowadays a three-bladed shutter that nearly

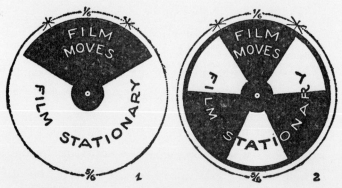

ILLUSTRATING THE PROPORTIONS OF LIGHT AND DARK PERIODS DURING PROJECTION IN TWO TYPES OF SHUTTERS.

1. Old single-blade type; caused a "flicker."
2. Regular three-blade type; light evenly distributed. It is to be noted that while the picture is on the screen two opaque sections of the shutter eclipse the light.

does away with an unsteady light is in general use. Its operation, approximately for the purposes of description is like this: It turns once in one-sixteenth of a second; one-sixth of this time is taken up with the moving of the film and the eclipsing of the light by one blade of the shutter. During the remainder of the time—five-sixths of it, the following takes place: the film is stationary and ready for projection, then two blades of the shutter and three of its open sections pass across the path of the light.

From this it can be seen that when the picture is viewed on the screen, there are actually two short moments when the light rays are cut off. This is not perceived by the spectator on account of the speed of the revolving shutter and the strong illuminant. Instead, the use of a shutter of this pattern evens the screen lighting by making an equal apportioning of light flashes and dark periods. With the old shutter there was one long period of light and one short period of darkness. It was this unequal distribution that gave rise to the flicker. At times, under certain conditions, a two-bladed shutter is used also.

A reel of film may vary in length for a short

subject of fifty feet (or even less), to a very long "feature" of a mile or so in length. In width, the strip of celluloid measures one and three-eighths inches. Between the two rows of perforations that engage with the teeth on the sprocket-wheels and by which a certain part of the intermittent mechanism pulls the film along, are little rectangular panels, already alluded to, containing the photographs. Sometimes these panels are called "frames," generally though, in the parlance of the trade, they are simply designated as "pictures." They measure one inch across and three-quarters of an inch in height.

As noted above, these frames contain photographs of scenes that record, by changes in their action, the incidents and episodes of the story of any particular reel. In the case of animated cartoons, the frames on the film also contain photographs, but these photographs are made from sets of progressive drawings depicting the action of the characters of the animated cartoon.

In concluding this brief account of the modern motion-picture, the attention is directed, as the subject is studied, to a few details of the mechanism and to the general procedure that are found to be

elementary features in
nearly all apparatus used
during the round of years
that the art was develop-
ing. They are as follows:
(1) A series of pictures—
drawings or photographs—
representing an action by
progressive changes in their
delineation. (2) Their pres-
entation, one at a time,
in rapid succession. (3)
Their synthesis, directly
upon the retina of the eye,
or projected on a screen and
then viewed by the eye.
(4) Some means by which
light—or the vision—is
shut off while the change
from one picture to an-
other is taking place. (Pro-
jecting machines have been

SECTION OF AN ANIMATED CAR-
TOON FILM.
Exact size.

made, however, in which the film is moved so rapidly, and in a particular way, that a shutter to eclipse the light is not needed.)

Now, as stated before, the phenomenon of the persistence of vision is the fundamental physiological fact upon which the whole possibility of seeing screen pictures rests. One of the first devices made that depended upon it, and that very simply demonstrated this faculty of the retina for holding a visional image for a time, was an optical toy called the thaumatrope. It dates from about 1826. It was a cardboard disk with two holes close to the edge at opposite points. Strings were passed through these holes and fastened and the dangling ends held and rolled between the thumbs and fingers so that the disk was made to twirl rapidly. Each side of the disk had a picture printed or drawn upon it. These two pictures when viewed together while the disk was twirled appeared as one complete picture. A favorite design for depiction was an empty bird-cage on one side and a bird on the other. The designs were placed with respect to each other in the same way as the marks and insignia of the two sides of most coins. (The coins of Great Britain are

an exception, on them the designs are placed differently. In reading their marks or looking at the images of the two sides, we turn the coin over like the page of a book.)

The thaumatrope illustrates the persistence of vision in a very elementary way. Simply explained, the face of one side of the disk with its design is before the eye, the design impresses its true image upon the retina, the disk turns away and the picture disappears, but its after-image remains on the retina. The disk having turned, brings the other picture into view. Its true image is impressed upon the retina to blend with the

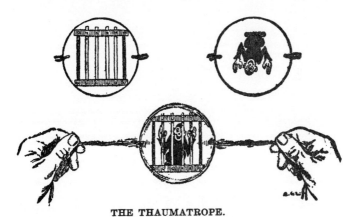

THE THAUMATROPE.

Above: How the designs of the two sides are placed with respect to each other.
Below: The combined image when the thaumatrope is twirled.

after-image of the first picture. In rapid sequence this turning continues and the two images commingle to give the fantasy of a perfect design.

A limited number of subjects only were suitable for demonstration by a toy of this character. Two other subjects were those showing designs to give the effect of a rider on a horse and a tight-rope dancer balanced on a rope.

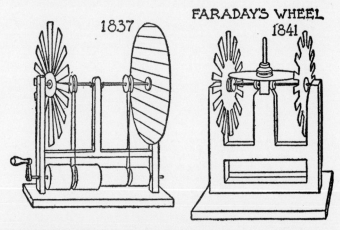

TWO INSTRUMENTS USED IN EARLY INVESTIGATIONS OF OPTICAL PHENOMENA.
From *The Saturday Magazine* of 1837 and 1841.

Later when scientific investigators were busy inquiring into the phenomena of visual distortions exhibited by the spokes and teeth of turning wheels

when seen in contrast with certain intervening
objects, a curious apparatus was contrived by
Faraday the English scientist (1791–1867). This
apparatus was so constructed that two disks were
made to travel, by cogged gearing, in opposite
directions, but at the same speed. Around the
circumferences of the disks were cut narrow slots
at equal distances apart and so making the solid
portions between them like teeth, or spokes of a
wheel.

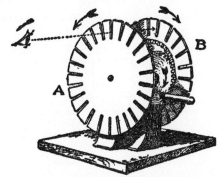

APPARATUS ON THE ORDER OF FARADAY'S WHEEL.
With the disks moving as marked, the disk *B* will appear to be motionless
when viewed through the passing slots of disk *A*.

When this machine was set in motion and the
eye directed through the moving and blurred
teeth of the front disk toward the far disk, this
far disk appeared to be stationary. Its outline—

the teeth, slots, and circumference—were distinctly seen and not blurred.

Then it was found that the same effect could be obtained with the use of one slotted disk by simply holding it in front of a mirror and viewing the reflected image through the moving slots of the disk. The reflection answered for the second disk of the instrument of the first experiment.

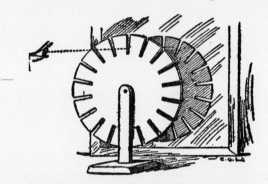

AN ANTECEDENT OF THE PHENAKISTOSCOPE.

When the disk is twirled the reflections of its spokes appear stationary when viewed through the moving slots.

From this type of optical toy it was but a step to the contriving of various types of instruments constructed on the pattern of a slotted disk, or some sort of a turning mechanism with a series of apertures, to use in giving the illusion of movement in connection with drawings or photographs.

The best-known was the phenakistoscope, the invention of which has been credited to the Belgian physicist, Plateau (1801–1883). This toy was a large cardboard disk with pictures on one side that were to be viewed by their reflections through slots in the disk while it was held before a mirror. The pictures drawn in sequence represented some action, as a horse running, an acrobat, a juggler, or some amusing subject that could be drawn easily in a cycle of actions and that would lend itself to repetition.

The phenakistoscope has some rough resemblance in its plan to a motion-picture projector— the cycle of slightly different drawings represents the film with its sequence of tiny pictures; the slots in the disk by which the drawings are viewed in the mirror correspond to the open sections of the revolving shutter; while the solid portions of the disk answer to the opaque parts of the shutter.

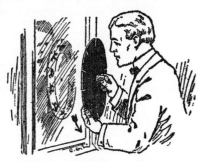

Holding a phenakistoscope before a mirror and ready to twirl it around.

As it only was possible in the phenakistoscope that one person at a time could view conveniently the reflected pictures, the attempt was made to arrange it for projection. A lens was added with a light and mirrors so that a number of people could see its operation at the same time. In another form the pictures were placed on a glass disk which was made to rotate back of a magic-lantern objective.

When the number of slots in a phenakistoscope correspond to the number of drawings in the cycle, the different figures of the cycle are in action but they do not move from the place where they are depicted. Only their limbs, if it is an action in which these parts are brought into play, are in movement. But if there is one slot more and the disk turned in the proper direction, the row of drawings will appear to be going around a circle.

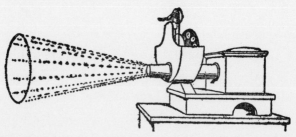

PHENAKISTOSCOPE COMBINED WITH A MAGIC-LANTERN.

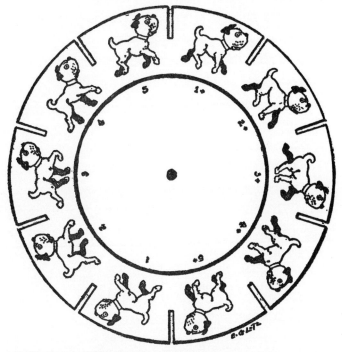

PHENAKISTOSCOPE WITH A CYCLE OF DRAWINGS TO SHOW
A DOG IN MOVEMENT.

This is particularly adapted to series of running animals.

Another method of giving the semblance of motion to a series of progressive drawings, soon devised after the invention of the phenakistoscope, was the zootrope, or wheel of life. It embodied the idea, too, of a rapidly moving opaque

flat portion with a row of slots passing between the eye and the drawings.

In form the zootrope was like a cylindrical lidless box of cardboard. It was pivoted and balanced on a vertical rod so that it could be made to turn easily and very rapidly. The slots were cut around the upper rim of the box. Long strips of paper holding pictures fitted into the box. When one of these strips was put in place, it was so adjusted that any particular drawing of the series could be viewed through a slot of the opposite side. These drawings appeared

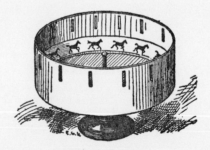

THE ZOOTROPE.

to be in motion when the zootrope was made to twirl.

This type of optical curiosity, as a matter of priority, is associated with the name of Desvignes,

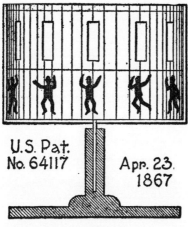

ZOETROPE OF WILLIAM LINCOLN.

as he obtained a patent for it in England in 1860.
Later in 1867, a United States patent was issued
for a similar instrument to William Lincoln, of
Providence, R. I. He called his device the
zoetrope.

This cylindrical synthesizing apparatus was
sold as a toy for many years. Bands of paper
with cycles of drawings of a variety of humorous
and entertaining subjects thereon were prepared
for use with it.

But the busy inventors were not satisfied with
the simple form in which it was first fabricated.
Very soon from the zootrope was evolved another

optical curiosity that preserved the general cylindrical plan, but made use of the reflective property of a mirror to aid the illusion. This was the praxinoscope of M. Reynaud, of France. He perfected it and adapted its principles to create other forms of rotating mechanisms harmonizing progressive drawings to show movement.

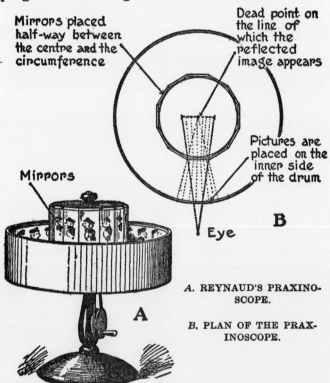

Mirrors placed half-way between the centre and the circumference

Dead point on the line of which the reflected image appears

Pictures are placed on the inner side of the drum

Mirrors

Eye

B

A

A. REYNAUD'S PRAXINO-
SCOPE.

B. PLAN OF THE PRAX-
INOSCOPE.

The praxinoscope held to the idea of a box, cylindrical and lidless, and pivoted in the centre so that it turned. The strip of drawings, and the plan of placing them inside of the box—two features of the zootrope—were both retained. But instead of looking at the drawings through apertures in the box rim, they were observed by their reflections in mirrors placed on an inner section or drum. The mirrors were the same in number as the drawings and turned with the rest of the apparatus. The mirrors were placed on the drum—the all-important point in the construction of the praxinoscope—half-way between the centre and the inner side of the rim of the box. As the drawings were placed here, the eye, looking over the rim of the box, viewed their reflections in the mirrors. But the actual place of a reflection was the same distance back of the surface of a mirror that a drawing was in front of it; namely, at the dead centre of the rotating cylinder. It was here, at this quiet point, that it was possible to see the changing images of the succession of graduated drawings blending to give the illusion of motion.

Reynaud next fixed his praxinoscope with im-

provements that made the characters in his draw-
ings appear to be going through a performance
on a miniature stage. He called his new con-
trivance the theatre praxinoscope. This new me-
chanism, was fixed in a box before which was

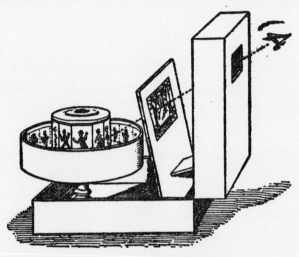

THE THEATRE PRAXINOSCOPE.

placed a mask-like section to represent a pro-
scenium. Another addition in front of this had a
rectangular peep-hole and small cut-out units of
stage scenery that were reflected on the surface
of a glass inserted into the proscenium opening.

Not satisfied with this toy theatre, Reynaud's

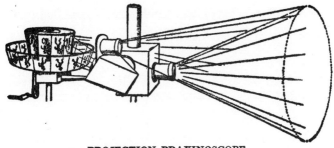

PROJECTION PRAXINOSCOPE.
(After picture in *La Nature*, 1882.)

next step was to combine with the praxinoscope, condensers, lenses, and an illuminant with which to project the images on a screen, so that spectators in an auditorium could see the illusion. A more intricate mechanism, again, was later devised by Reynaud. This was his optical theatre in which there was used an endless band of graduated drawings depicting a rather long pantomimic story. It, of course, was an enlargement of the idea of the simple early form of praxinoscope with its strip of paper containing the drawings. But this optical theatre had such a complication of mirrors and lenses that the projected light reached the screen somewhat diminished in illuminating power, and the pictures were consequently dimmed.

From the time of the invention of the thauma-
trope in 1826, and throughout the period when
the few typical machines noted above were in
use, drawings only in graduated and related series,
were applied in the production of the illusion of
movement.

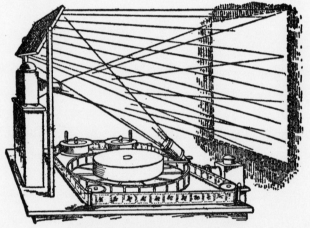

OPTICAL THEATRE OF REYNAUD.
(After picture in *La Nature*, 1892.)

Drawings, too, were first employed for a little
optical novelty in book-form, introduced about
1868, called the kineograph. It consisted of a
number of leaves, with drawings on one side,
firmly bound along an edge. The manner of its
manipulation was to cause the leaves to flip from

under the thumb while the book was held in the hands. The pictures, all of a series depicting some action of an entertaining subject, passed quickly before the vision as they slipped from

under the thumb and give a continuous action of the particular subject of the kineograph.

Now when the camera began to be employed in taking pictures of figures in action, one of the first uses made of such pictures was to

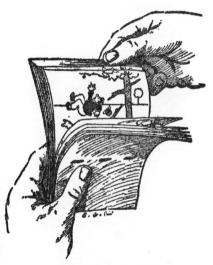

THE KINEOGRAPH.

put a series of them into the book-form so as to give, by this simple method of allowing the leaves to flip from under the thumb, the visional deception of animated photographs.

THE GENESIS OF MOTION-PICTURES

CHAPTER II

THE GENESIS OF MOTION-PICTURES

ALTHOUGH the possibilities of taking pictures photographically was known as early as the third decade of the nineteenth century, drawings only were used in the many devices for rendering the illusion of movement. In the preceding chapter in which we have given a brief history of the early efforts of synthesizing related pictures, typical examples of such instruments have been given. But the pictorial elements used in them were always drawings.

It was not until 1861 that photographic prints were utilized in a machine to give an appearance of life to mere pictures. This machine was that of Mr. Coleman Sellers, of Philadelphia. His instrument brought stereoscopic pictures into the line of vision in turn where they were viewed by stereoscopic lenses. Not only did this arrangement show movement by a blending of related pictures but procured an effect of relief.

It is to be remembered that in the days of Mr. Sellers, photography did not have among its means any method of taking a series of pictures on a length of film, but the separate phases of a move-

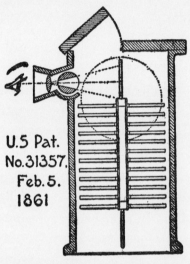

U.5 Pat. No.31357. Feb.5. 1861

PLAN OF THE APPARATUS OF COLEMAN SELLERS FOR GIV-ING THE ILLUSION OF LIFE TO A SERIES OF PHOTOGRAPHS.

ment had to be taken one at a time on plates. The ribbon of sensitized film, practical and dependable, did not come until more than twenty-five years later. Its introduction into the craft was coincident with the growth of instantaneous photography.

When scientists began to study movement with the aid of instantaneous photographs, they quite naturally cared less for synthesizing the pictorial results of their investigations than they did for merely observing and recording exactly how movement takes place.

At first diagrams and drawings were used by students of movement to fix in an understandable way the facts gained by their inquiries. In England, for instance, Mr. J. Bell Pettigrew (1834–1908) illustrated his works with a lot of carefully made diagrammatic pictures. He made many interesting observations on locomotion and gave much attention to the movement of flying creatures, adding some comment, too, on the possibility of artificial flight.

Again in Paris, M. E. J. Marey (whose work is to be considered a little farther on) embellished his writings with charts and diagrams that were made with the aid of elaborate apparatus for the timing of animals in action and the marking of their footprints on the ground. Then he traced, too, by methods that involved much labor and patience, the trajectory of a bird's wing. And in his continued searching out of the principles

of flight registered by ingenious instruments the wing-movements in several kinds of insects.

In our first chapter no instructions were given as to how animated cartoons are made. And although this is the specific purpose of the book, we must again in this chapter refer but slightly to the matter, as there is need that we first devote some time to chronicling the early efforts in solving animal movements by the aid of photography. Then we must touch, too, upon the modes of the synthesis of analytic photographs for the purpose of screen projection.

Both these matters are pertinent to our theme: the animated screen artist makes use of instantaneous photographs for the study of movement, and the same machine that projects the photographic film is also used for the animated cartoon film made from his drawings.

What appears to have been the first use of photographs to give a screen synthesis in an auditorium, was that on an evening in February, 1870, at the Academy of Music, in Philadelphia. It was an exhibition given by Mr. Henry R. Heyl, of his phasmatrope. He showed on a screen, life-sized figures of dancers and acrobats in motion.

The pictures were projected, with the aid of a magic-lantern, from photographs on thin glass plates that were placed around a wheel which was made to rotate. A "vibrating shutter" cut off the light while one photograph moved out of the way, and another came in to take its place. The wheel had spaces for eighteen photographs. It was so planned that those of one set could be taken out and those of another slipped in to change a subject for projection.

The photographs used in the phasmatrope were from posed models; a certain number of which were selected to form a cycle so that the series could be repeated and a continuous performance be given by keeping the wheel going. At this period there were no pliant sensitized ribbons to take a sequence of photographs of a movement, and Heyl had to take them one at a time on glass plates by the wet collodion process.

A notable point about this early motion-picture show was that it was quite like one of our day, for according to Heyl, in his letter to the *Journal of the Franklin Institute,* he had the orchestra play appropriate music to suit the action of

the dancers and the grotesqueries of the acrobats.

Better known in the fields of the study of movement and that of instantaneous photography and pictorial synthesis are M. Marey, already mentioned (1830–1904), and his contemporary, Mr. E. Muybridge (1830–1904). While Marey conducted his inquiries in Paris, Muybridge pursued his studies in San Franscisco and Philadelphia.

Marey, who in the beginning recorded the changes and modification of attitudes in movement by diagrams and charts, later used diagrams made from photographs and then photographs themselves. He studied the phases of movement from a strictly scientific standpoint, in human beings, four-footed beasts, birds, and nearly all forms of life. And he did not neglect to note the speed and manner of moving of inorganic bodies, such as falling objects, agitated and whirling threads.

Muybridge, on the other hand, seemed to have a trend toward the educational, in a popular sense of the word; and had a faculty of giving his works a pictorial quality. He showed this in the choice of his subjects and the devising of machines

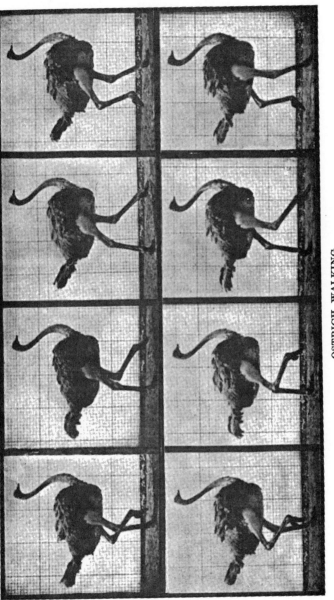

OSTRICH WALKING.

Part of a plate in Muybridge's "Animal Locomotion." Published and copyrighted by him in 1887.

An imposing work, made under the auspices of the University of Pennsylvania, of more than 700 large plates. It was the first comprehensive analytical study of movement in human figures and animals.

that combined his photographs somewhat successfully in screen projection.

In Muybridge's first work in which he photographed a horse in motion, he used a row of cameras in front of which the horse proceeded. The horse in passing before them, and coming before each particular camera, broke a string connected with its shutter. This in opening exposed the plate and so pictured the horse at that moment, and in the particular attitude of that moment. This breaking of a string, opening of a shutter, and so on, took place before each camera. Muybridge in his early work used the collodion wet plate, a serious disadvantage. Later he had the convenience of the sensitized dry plate and was also able to operate the cameras by motors.

When Marey began to employ a camera in his researches he registered the movements of an entire action on one plate; while Muybridge's way was to take but one phase of an action on one plate. The two men differed greatly in their objects and methods. Marey in his early experiments, at least, traced on one plate or chart the successive changes in attitudes of limbs or parts, or the positions of certain fixed points on his

models. But Muybridge procured single but related pictures of attitudes assumed by his subjects in a connected and orderly sequence. The latter method lent itself more readily to adaptation for the projecting lantern and so became popularly appreciated. Perhaps it is for this reason that Muybridge has been referred to as the father of the motion-picture.

The photographic gun was Marey's most novel camera. With this he caught on a glass plate the movements of flying birds. This instrument was suggested by a similar one used by M. Janssen, the astronomer, in 1874, to make a photographic record of the transit of a planet across the sun's disk.

The kineograph, mentioned at the beginning

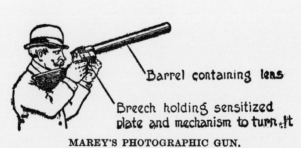

Barrel containing lens

Breech holding sensitized plate and mechanism to turn it

MAREY'S PHOTOGRAPHIC GUN.

of this chapter, by which the illusion of motion was given to a series of pictures arranged like a book, formed the basic idea for a number of other popular contrivances. One of these was the mutoscope, in which the leaves were fastened by one edge to an axis in such a way that they stood out like spokes. The machine in operation brought one leaf for a moment

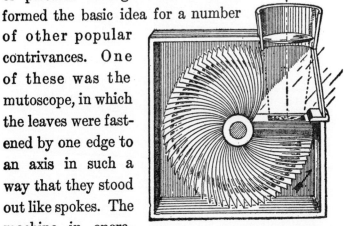

PLAN OF LUMIÈRE'S KINORA.
An apparatus similar in principle to the mutoscope.

leaf for a moment at rest under the gaze of the eye and then allowed it to snap away to expose another picture in its place. When this was viewed in its turn, it also disappeared to make way for the next in order.

As yet experimenters were not altogether sure in what particular way to combine a series of graduated pictures so as to produce one living image. Besides the ways that have been ex-

emplified in the apparatus so far enumerated, some experimenters tried to put photographs around the circumference of a large glass disk somewhat on the order of the phenakistoscope. Heyl's phasmatrope, of 1870, was on this order.

On this plan of a rotating disk, Muybridge constructed his zoöpraxiscope by which he projected some of his animal photographs. Another expedient tried by some one was that of putting a string of minute pictures spirally on a drum which was made to turn in a helix-like fashion. The pictures were enlarged by a lens and brought into view back of a shutter that worked intermittently.

Although the dry plate assuredly was a great improvement over the slow and troublesome old-fashioned wet plate, there was felt the need of some pliant material that could be sensitized for photography and that could furthermore be made in the form of a ribbon. The suitableness of the paper strips for use in the zootrope and the praxinoscope obviously demonstrated the advantages of an elongated form on which to put a series of related pictures.

Experiments were made to obtain a pliant

ribbon for the use. Transparent paper was at one time tried but found unadaptable. Eventually the celluloid film came into use, and it is this material that is now generally in use to make both the ordinary snap-shot film and the "film stock" for the motion-picture industry.

Edison's kinetoscope of 1890, or more particularly its improved form of 1893, that found immediate recognition on its exhibition at the Word's Fair at Chicago, was the first utilization on a large scale of the celluloid film for motion-pictures. It is to be remarked, however, that in the kinetoscope the pictures were viewed, not on a screen in an auditorium by a number of people, but by one person at a time peering through a sight opening in the apparatus. It was the kinetoscope, it appears, that set others to work devising ways of using celluloid bands for projecting pictures on a screen.

While some inventors were busy in their efforts to construct workable apparatus both for photography and projection, others were endeavoring to better the material for the film and improve the photographic emulsion covering it.

There is no need in this book, in which we shall

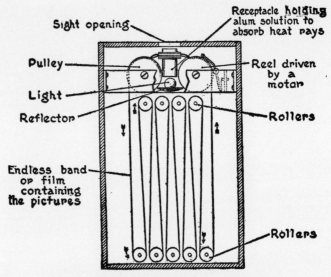

Sight opening

Receptacle holding alum solution to absorb heat rays

Pulley

Reel driven by a motor

Light

Reflector

Rollers

Endless band of film containing the pictures

Rollers

PLAN OF EDISON'S FIRST KINETOSCOPE.
Modified from the Patent Office drawing.

try to explain the making of animated screen drawings, to recount the whole story of the progressive improvements of the machines used in the motion-picture industry. But a short notice of the present-day appliances will not be out of place.

The three indispensable pieces of mechanism are the camera, the projector, and the printer, or apparatus that prints pictures photographically. All three in certain parts of their construction

are similar in working principles. The mechanical arrangements of the camera and projector especially are so much alike that some of the first apparatus fabricated were used both for photography and projection. A few early types of cameras served even for printers as well.

The essential details of the three machines named above can be described briefly as follows: (1) A camera has a light-tight compartment within which a fresh strip of film passes and stops intermittently back of a lens that is focussed on a subject, a rotating shutter with an open and an opaque section makes the exposure. (When the strip of film is developed it is known as the negative.) (2) A printer pulls the negative, together with a fresh strip of film in contact with it, into place by an intermittent mechanism before a strong light. A rotating shutter flashes the light on and off. (The new piece of film, when it is developed and the pictures are brought out, is known as the positive.) (3) The projector moves the positive film by an intermittent mechanism between a light and a lens; a rotating shutter, with open and opaque sections, alternately shuts the light off and on. When the light rays are

allowed to pass the pictures contained on the positive film are projected on the screen.

It seems unnecessary, perhaps, in these days of the ubiquity of snap-shot cameras, and the fact that nearly every one becomes acquainted with their manipulation, to mention that a photo-

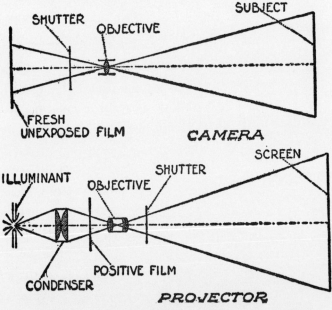

PRINCIPLES OF THE PROJECTOR AND THE MOTION-PICTURE CAMERA COMPARED.

graphic negative records the light and shade of nature negatively, and that a positive print is

one that gives a positive representation of such light and shade.

A motion-picture camera of the most approved pattern is an exceedingly complicated and finely adjusted instrument. Its principle of operation can be understood easily if it is remembered that it is practically a snap-shot camera with the addition of a mechanism that turns a revolving

A NEGATIVE.

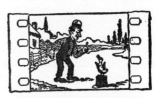

A POSITIVE PRINT.

shutter and moves a length of film across the exposure field, holds it there for an interval while the photographic impression is made, and then moves it away to continue the process until the desired length of film has been taken. This movement, driven by a hand-crank, is the same as that of a projector—previously explained—namely, an intermittent one.

This is effected in a variety of ways. The method in many instruments is an alternate one of the going back and forth of a pair of claw-levers

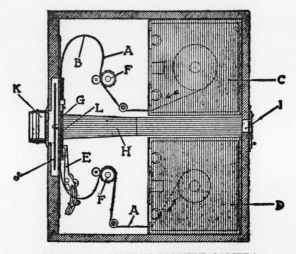

PLAN OF A MOTION–PICTURE CAMERA.

A. Film. *B.* Top loop to allow for the pulling down of the film during the intermittent movement. *C.* Magazine to hold the blank film. *D.* Magazine to hold the exposed film. *E.* Claw device which pulls down the film three-quarters of an inch for each picture. *F.* Sprocket-wheels. *G.* Exposure field. *H.* Focusing-tube. *I.* Eye-piece for focusing . *J.* Shutter. *K.* Lens. *L.* Film gate.

that during one such motion draw the film into place by engaging the claws into perforations on the margins of the film.

The patterns of the shutters in camera and projector differ. That of the projector is three or two parted, as stated in our observations previously made. A camera shutter is a disk with an open section. The area of this open section can be varied to fit the light conditions.

The general practice relative to taking motion-pictures is to have one-half foot of film move along for each turn of the camera handle. Eight separate pictures are made on this one-half foot of film. But in a camera that the animated cartoon artist uses, but one turn of the handle for each picture is the method. In most cameras the gearing can be changed to operate either way. To photograph drawings in making animated films a good reliable instrument is necessary, and requirements to the purpose should be thought of in selecting one. One important matter that may be mentioned here is that there

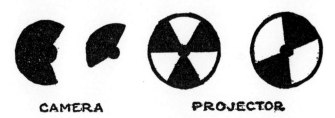

CAMERA PROJECTOR

TYPES OF CAMERA AND PROJECTOR SHUTTERS.

should be an easy way of focussing the scene. Generally in taking topical pictures and views, an outside finder and a graduated scale for distance and other matters is made use of, but for

drawings it is essential to be able to focus on a suitable translucent surface within the exposure field in the camera.

There are certain numerical formulas that those going into motion-picture work should learn at the start. It is well, too, for the general reader, even if he is interested only as a matter of information to take note of them. Their comprehension will help to a better understanding of how both the ordinary photographic film, and the film from animated drawings, are made, prepared, and shown on the screen.

As the ordinary phrase goes, any single subject in film form is spoken of as a reel; but in strict trade usage the word means a length of one thousand feet. As it is generally reckoned, sixty feet of film pass through the projecting machine every minute. This means that a reel of one thousand feet will take about seventeen minutes. Now with sixty feet of film crossing the path of light in one minute, we see that one foot hurries across in one second. And as sixteen little pictures are contained in one foot of film, we get an idea of the great number of such separate pictures in a reel of ordinary length.

All these particulars—especially that regarding the speed at which the film moves—are vital matters for the animated cartoon artist to keep in mind as he plans his work.

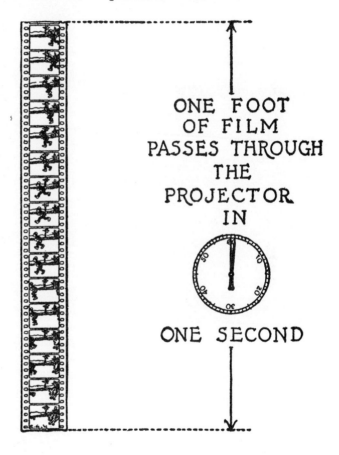

ONE FOOT
OF FILM
PASSES THROUGH
THE
PROJECTOR
IN

ONE SECOND

MAKING ANIMATED CARTOONS

CHAPTER III

MAKING ANIMATED CARTOONS

IN the preceding chapter the attention was called to the fact that a foot of film passes through the projector in one second, and that in each foot there are sixteen pictures, or frames, within the outlines of which the photographic images are found. When a camera man sets up his apparatus before a scene and starts to operate the mechanism, the general way is to have the film move in the camera at this same rate of speed; to wit, one foot per second. As each single turn of the camera handle moves only one-half of a foot of film, the camera man must turn the handle twice in one second. And one of the things that he must learn is to appraise time durations so accurately that he will turn the handle at this speed.

The animated cartoon artist, instead of using real people, objects, or views to take on his film, must make a number of related drawings, on every one of which there must be a change in a proper,

progressive, and graduated order. These drawings are placed under a camera and photographed in their sequence, the film developed and the resultant negative used to make a positive film. This is used, as we know, for screen projection. All the technical and finishing processes are the same whether they are employed in making the usual reel in which people and scenes are used, or animated cartoon reels from drawings.

When it is considered that there are in a half reel (five hundred feet, the customary length for a comic subject) exactly eight thousand pictures, with every one—theoretically—different, it seems like an appalling job to make that number of separate drawings for such a half reel. But an artist doesn't make anywhere near as many drawings as that for a reel of this length, and of all the talents required by any one going into this branch of art, none is so important as that of the skill to plan the work so that the lowest possible number of drawings need be made for any particular scenario.

"Animator" is the special term applied to the creative worker in this new branch of artistic endeavor. Besides the essential qualification of

bestowing life upon drawings, he must be a man of many accomplishments. First as a scenario is always written of any screen story no matter whether serious, educational, or humorous, he must have some notion of form; that is to say, he must know what good composition means in putting components together in an orderly and proportional arrangement.

If the subject is an educational one he must have a grasp of pedagogical principles, too, and if it is of a humorous nature, his appreciation of a comic situation must be keen.

And then with the terrifying prospect confronting him of having to make innumerable drawings and attending to other incidental artistic details before his film is completed, he must be an untiring and a courageous worker. His skill as a manager comes in when planning the whole work in the use of expedients and tricks, and an economy of labor in getting as much action with the use of as few drawings as possible.

Besides the chief animator, others, such as assistant animators, tracers, and photographers, are concerned in the production of an animated film from drawings.

Comments on the writing of the scenario we do not need to go into now. Often the artist himself writes it; but if he does not, he at least plans it, or has a share in its construction.

Presuming, then, that the scenario has been written, the chief animator first of all decides on the portraiture of his characters. He will proceed to make sketches of them as they look not only in front and profile views, but also as they appear from the back and in three-quarter views. It is customary that these sketches—his models, and really the dramatis personæ, be drawn of the size they will have in the majority of the scenes. After the characters have been created, the next step is to lay out the scenes, in other words, plan the surroundings or settings for each of the different acts. The rectangular space of his drawings within which the composition is contained is about ten or eleven times larger than the little three-quarter-by-one-inch pictures of the films; namely, seven and one-half by ten inches, or eight and one-quarter by eleven inches. For some kinds of films—plain titles and "trick" titles —the making of which will be remarked upon further on—a larger field of about thirteen and one-half by eighteen inches is used.

Now with a huge pile of white linen paper cut to a uniform size of about nine by twelve inches, the animator apportions the work to the several assistant animators. The most important scene or action, of course, falls to his share. There are several ways of going about making animated cartoons, and trick titles, and these methods will be touched upon subsequently. But in the particular method of making animated cartoons

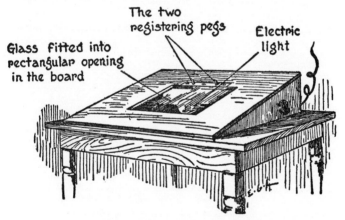

The two
registering pegs

Electric
light

Glass fitted into
rectangular opening
in the board

"ANIMATOR'S" DRAWING–BOARD.

which we are describing now—that in which paper is the principal surface upon which the drawings are made in ink—all the workers make their drawings over a board that has a middle portion cut out and into which is fitted a sheet

of thick glass. Under this glass is fixed an electric light. On the board along the upper margin of the glass, there is fixed to the wood a bar of iron to which two pins or pegs are firmly fixed. These pegs are a little less than one-half inch high and distant from each other about five inches. It doesn't matter much what this distance is, excepting this important point: all the boards in any one studio must be provided with sets of pegs that are uniform with respect to this distance between them. And all of them should be most accurately measured in their placing. Sometimes as an expedient, pegs are merely driven into the board at the required distance.

These pegs are seven thirty-seconds of an inch in diameter. That the animator should use this particular size of pegs was determined, no doubt, by the fact that an article manufactured originally for perforating pages and sheets used in certain methods of bookkeeping was found available for his purposes. This perforator cuts holes exactly seven thirty-seconds of an inch in diameter. Each one of the sheets of paper from the huge pile spoken of above, before it is drawn upon, has two holes punched into one of its long edges at

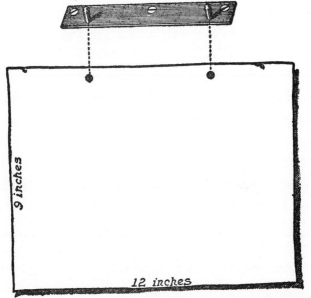

A SHEET OF PERFORATED PAPER AND THE REGISTERING
PEGS.

the same distance apart as the distance between
the two pegs fixed to the animator's drawing-
board.

Fitting one of these sheets of paper over the
pegs, the artist-animator is ready for work. As
the paper lies flat over the glass set into the board,
he can see the glare of the electric light under-
neath. This illumination from below is to enable
him to trace lines on a top sheet of paper from

lines on a second sheet of paper underneath; and also to make the slight variations in the several drawings concerned in any action.

Now the reason for the pegs is this: as in an ordinary motion-picture film certain characters, as well as objects and other details are quiescent, and only one or a few characters are in action, so in an animated cartoon some of the figures, or details, are quiescent for a time. And as they stay for a length of time in the same place in the scene, their portrayal in this same place throughout the series of drawings is obtained by tracing them from one sheet to another. The sheets are held in place by the pegs and they insure the registering of identical details throughout a series.

When the animator designs his setting, the stage scenery of any particular animated play, he keeps in mind the area within which his figures are going to move. Reasons for this will become apparent as the technic of the art is further explained. The outline of his scene, say a background, simply drawn in ink on a sheet of paper is fitted over the pegs. The light under the glass, as explained immediately above, shows through

it. Next a fresh sheet of paper is placed over the one with the scene, and as the paper is selected for its transparent qualities, as well as its adaptability for pen-drawing, the ink lines of the scene underneath are visible.

Let us presume now, that the composition is to represent two men standing and facing each other and talking. They are to gesticulate and move their lips slightly as if speaking. (In the following description we will ignore this movement of the mouth and have it assumed that the artist is drawing this action, also, as he proceeds with the work.) The two men are sketched in some passive position, and the animation of one of the figures is started. With the key sketch of the men in the passive position placed over the light, a sheet of paper is placed over it and the extreme position of a gesticulating arm is drawn, then on another sheet of paper placed over the light the other extreme position of this arm action is drawn. Now, with still another sheet of paper placed over the others, the intermediate position of the gesture is drawn. As the man was standing on the same spot all the time his feet would be the same in all the drawings and

other parts of his figure would occupy the same place. But the animator does not draw these parts himself but marks the several sheets where they occur with a number, or symbol, that will be understood by one of his helpers—a tracer— as instructions to trace them. The other man in the picture, who all this time has been motionless, is also represented in all the drawings line for line as he was first drawn in the preliminary key sketch. This again is a job for the tracer.

When the action of the second figure is made, the drawing of the three phases of movement in his arms is proceeded with in the same way, and the first figure is repeated in his passive position during the gesturing of the second man.

It can be seen from this way of working in the division of labor between the animator and his helper that the actual toil of repeating monotonous details falls upon the tracer. The animator does the first planning and that part of the subsequent work requiring true artistic ability.

So that the artists can see to do the work described above—tracing from one sheet of paper to another and distinguishing ink lines through two or more sheets of paper while they are over

COMPLETE SCENE

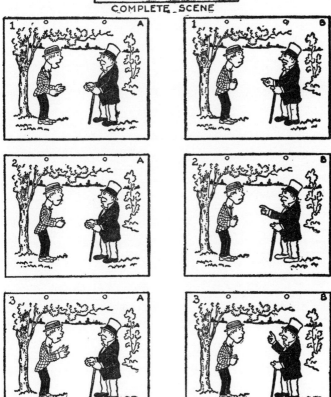

ILLUSTRATING THE GREAT AMOUNT OF DRAWING RE-
QUIRED IN ANIMATING A SCENE WITHOUT THE HELP OF
TRANSPARENT CELLULOID.

the illuminated glass—the expedient is adopted
of shading the work-table from the glare of strong
daylight.

In this typical process of depicting a simple
action, or animating a figure, as it is called, we
have left out specific explanations for drawing the
details of the scenery—trees, foreground, or what-
ever is put into the composition as an accessory.
They go into a finished composition, to be sure.
One way would be to trace their outlines on each
and every sheet of paper. It is a feasible way
but not labor-saving. There is a much more
convenient way than that.

In beginning this exposition on animation it
was noted that the artist in designing the scenery
gave some thought to the area within which his
figures were placed, or were to act. He planned
when he did this, that no part of the components
of the scenery should interfere by crossing lines
with any portions of the figures. The reason for
this will be apparent when it is explained that
the scenery is drawn on a sheet of transparent
celluloid. Then when the celluloid with its scenery
is placed over one of the drawings it completes
the picture. The celluloid sheet has also two

perforations that fit over the pegs, and it is by their agency that its details are made to correspond with the drawings on paper. And it can further be understood that this single celluloid sheet will complete, if it is designed properly, the pictorial composition of every one of the drawings. (A sheet of this substance that we are referring to now is known in the craft as "a celluloid" or shortened sometimes to "cell.")

The employment of celluloid can be extended to save other work in tracing parts of figures that are in the same position, or that are not in action throughout several drawings. In this case a second celluloid will be used in conjunction with that holding the scenery. To exemplify: In giving an account of the drawing of the arm gestures in the instance above, it was noted that an animator drew the action only while he had a tracer complete on all the drawings the parts that did not move. Now, to save the monotony of all this, the tracer takes celluloid and draws the similarly placed quiet parts on it but once. This celluloid is used during the photography with the several action phases to complete the picture of the figure, or figures.

A matter that the animator should guard against, however, in having several celluloids over his drawings, during the photography, is that they will impart a yellowish tinge to his white paper underneath if he uses more than two or three. This would necessitate care in timing the exposure correctly as a yellow tint has non-actinic

Scenery, drawn on celluloid, used with the elements on the opposite page.

qualities that make its photography an uncertain element.

The methods so far described of making drawings for animated films are not complex and are easy to manage. For effective animated scenes, many more drawings are required and the adaptation of celluloids is not always such an easy matter as here described. For complete films of ordinary length, the drawings, celluloids, and other items —expedients or ingenious devices to help the work —number into the hundreds.

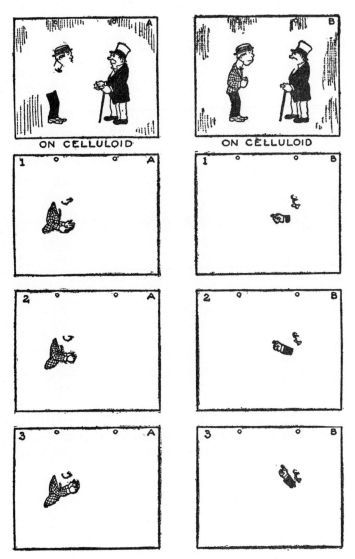

ON CELLULOID ON CELLULOID

ILLUSTRATING THE SAVING OF TIME AND LABOR IN MAK-
ING USE OF THE EXPEDIENT OF DRAWING THE STILL
PARTS ON CELLULOID SHEETS.

71

We will use, however, our few drawings and celluloids that we have completed to explain the subsequent procedure in the making of animated cartoons; namely, the photographic part of the process.

A moving-picture camera is placed on a framework of wood, or iron, so that it is supported over a table top or some like piece of carpentry. It is placed so that it faces downward with the lens centred on the table. The camera is arranged for a "one picture one turn of the crank" movement, and a gearing of chain belts and pulleys, to effect this, is attached to the camera and framework. This gearing is put into motion by a turning-handle close to where the photographer is seated as he works before the table top where the drawings are placed.

Each time the handle is turned but one picture, or one-sixteenth of a foot of film, is moved into the field back of the lens where the exposure is made. The view or studio camera, as we know, when a complete turn of the crank handle is made, moves eight pictures, or one-half of a foot of film, into position.

On the table directly under the lens and at

the proper distance for correct focussing, a field
is marked out exactly that of the field that was
used in making the drawings. Two registering
pegs are also fastened relatively to the field as
those on all the drawing-boards in the studio.
Over the field, but hinged to the table top so that
it can be moved up and down, a frame holding
a clear sheet of glass is placed. The glass must
be fitted closely and firmly in the frame, as it is
intended to be pressed down on the drawings
while they are being photographed. Wood serves
the purpose very well for these frames. A metal
frame would seem to be the most practical, but
if there is in its constructon the least inequality
of surface where glass and metal touch, the pres-
sure put upon the frame in holding the drawings
down is liable to crack the glass. With wood, as
there is a certain amount of give, this is not so
likely to happen.

Considering now that the camera has been
filled with a suitable length of blank film and
properly threaded in and out of the series of wheels
that feed it to the intermittent mechanism, and
then wind it up into its proper receptacle, we can
proceed with the photography.

The pioneers in the art who first tried to make animated cartoons and similar film novelties attempted the photography by daylight. Their results were not very good, for they were much handicapped by the uncertainty of the light. Nowadays the Cooper Hewitt mercury vapor light is used almost exclusively. The commonest method of lighting is to fix a tube of this illuminant on each side of the camera above the board, but so placed that light rays do not go slantingly into the lens, or are caught by any polished surface, and so cause reflected lights that interfere with the work. To get the exact position of the light for an even illumination over the field means a little preliminary experiment.

In looking over the material for our little film we find that we have but a few drawings and celluloids. Now, if we were to photograph them and give each drawing one exposure—one picture, or section on the film for each drawing— we should get a length of film not even a foot long, and the time on the screen not even lasting a second, but an insignificant result for so much work. Here at this stage of the work the able animator must exercise his talents in getting as

much film as possible, *i. e.,* "footage," out of his few drawings.

To begin: The first drawing in which the men

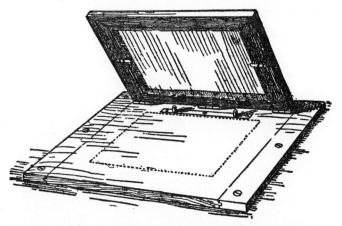

ARRANGEMENT OF BOARD, PEGS, AND HINGED FRAME WITH GLASS.

(For its position under the camera, see engraving on page 203.) A per-forated sheet of paper holding a drawing is fitted over the pegs and the frame lowered.

are quiescent is fitted over the pegs; but the picture is not complete until the celluloid with the scenery is also fitted over the pegs. When this is put in place and the frame with the glass is pressed down it is ready for photography. The first figures will not begin to gesticulate imme-diately—no, a certain time is necessary for the audience to appreciate—have enter into their con-

sciousness—that the picture on the screen represents two men facing each other and about to carry on a conversation. Therefore the drawing showing the men motionless is photographed on about two or three feet of film. This will give on the screen just so many seconds—two or three —for the mental grasping by the audience of the particulars of the pictorial composition. Next to show the first figure going through his movements we lift the framed glass and take off the celluloid with the scenery and the paper with the two men motionless. Now we put down over the pegs the sheet of paper with one of the extreme positions of the moving arms, and then as that is all there is on the paper we must, to complete the portrayal, place over it the celluloid with the rest of his figure. (This celluloid also holds the complete drawing of the other individual as he is motionless during the action of the first one.) Next the entire composition is completed by putting down the scenery celluloid. Then when the framed glass is lowered and pressed down so that everything presents an even surface, the picture is photographed. After two

turns of the handle—photographing it on two sections of the film—the frame is raised and the celluloids and the drawing are both taken off of the pegs. The photographing of the second or intermediate position is proceeded with in the same way. After this the third or other extreme phase of the action is photographed.

The photography is continued by taking the intermediate phase again, then the first position, then back to the intermediate one, and so on. The idea is to give a gesticulating action to the figure by using these three drawings back and forth in their order as long as the story seems to warrant it.

It is not to be forgotten that the celluloid with the scenery is used every time the different action phases are photographed.

The same procedure will be followed with the celluloid and drawings of the other figure, only before beginning his action a little extra footage can be eked out by giving a slight dramatic pause between the ending of the first man's gesticulating and the beginning of that of the other one. By this is meant that the first scene with the

men motionless is taken on a short length of film.

In a little incident of this sort, dialogue, of course, is required to help tell the point of the story. This is effected by putting the wording on a separate piece of paper—balloons, they are called—for each case and placing it over the design somewhere so that it will not cover any important part of the composition. The neces-

BALLOONS.

sary amount of film for one of these balloons with its lettering is determined by the number of seconds that it takes the average spectator to read it. It is by the interjection of these balloons with their dialogue that an animator, in comic themes, can

get a considerable length of film from a very few drawings.

After the photography is finished the exposed film is taken out of the camera and sent to the laboratory for development.

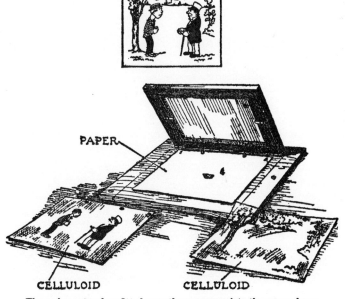

PAPER

CELLULOID CELLULOID

Three elements when fitted over the pegs complete the scene above.

FURTHER DETAILS ON MAKING
ANIMATED CARTOONS

CHAPTER IV

FURTHER DETAILS ON MAKING ANIMATED CARTOONS

ONE of the inspiriting things about this new art of making drawings for animated cartoons is that it affords such opportunities for a versatile worker to exercise his talents. A true artist delights in encountering new problems in connection with his particular branch of work. The very fact that he selects as his vocation some art activity, rather than employment that is mechanical, evinces this.

In making drawings for animated films and in following the whole process of their making, the artist will find plenty of scope for his ingenuity in the devising of expedients to advance and finish the work.

The first animated screen drawings were made without the labor and time-saving resources of the celluloid sheet. As has been explained, it holds the still parts of a scene during the photography. The employment of this celluloid is now

in common usage in the art. It is found an expedient in various ways; sometimes to hold part only of a pictorial composition as in the method touched upon in the preceding chapter where ink drawings are made on paper; or, again, in another method to be used instead of paper, to hold practically all of the picture elements. By this latter method, in which a pigment is also put on the transparent material, the projected screen image is in graduated tones giving the appearance of a monochrome drawing.

Animators sometimes are released from the irksomeness of making the innumerable drawings for certain cases of movement, as that of an object crossing the picture field from one side to the other, by using little separate drawings cut out in silhouette.

It is an airplane, as an instance, we will say, that is to fly across the sky. For this, the airplane will be drawn but once on a piece of thin cardboard, finished in light and shade and then carefully cut out around its contour so that it will be like a flattened model. This model, specifically spoken of as a "cut-out," is pushed over the background under the camera and photo-

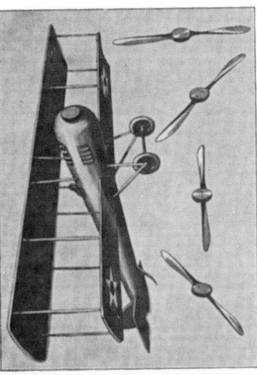

CARDBOARD MODEL OF AN AIRPLANE WITH SEPARATE CUT-OUT PROPELLERS.

The propellers are placed in position on the front of the airplane in their order continuously while the model, under the camera, is moved across the sky.

On the left: Part of film made from the cut-out model.

graphed. The manipulation of this airplane cut-out, to a chance observer, would be thought of as being child's play. It is anything but that, however, as infinite patience is required to move it properly and have the distances between the various positions evenly spaced. If, too, there is a change of speed intended, the necessary ratio of spacing and timing must be relatively proportionate. Of course, it is understood that the airplane cut-out is, after each move, photographed. The distance that it is moved determines the speed that will show on the screen. If, for example, it is moved only one-sixteenth of an inch each time, the movement will be very slow.

When an artist wishes to give a more natural effect in a moving object in which a cut-out is used, he makes some allowance for the laws of perspective by making several cut-outs in which the outlines defining the object observe these laws to some extent.

It is to be remembered that an object looks differently according to whether it is viewed on an extreme side or in the centre of the field. To be absolutely correct, there should be a separate drawing for each position. To explain: Begin-

The laws of perspective are to be considered in "animating" an object
as it passes across the screen.

ning with an extreme side position, the lines de-
fining the thickness go off somewhat obtusely to
the centre of vision; as the object moves and
nears the middle, these lines keep their direction
but change their angle. The direction is always
toward the centre of vision, and the angle, with
respect to a vertical, is always sharper. In the
very centre, the object, if it is on a level with
the eye, is in profile.

The entire matter is one of a different perspec-
tive drawing for each position. In the movement
of the subject toward the other side a reverse
change takes place in the direction of the lines.
Generally only a few separate drawings—or cut-
outs—are needed to render the screen illusion
sufficiently resembling actuality to satisfy the eye.

There is a form of animated cartoon in which

The principles of perspective are applied in the drawing of birds as well as in the picturing of objects.

the objects, details of the view, and the figures are in white on a black ground. Usually this kind of film is of a comic subject. With the delineations of the characters in a burlesque style and the actions indubitably ludicrous, they provoke a great deal of laughter. Such screen stories, when the figures are well imagined and drawn in an exaggerated way, and the other parts are conformably incongruous and with a unity of ridiculousness and absurdity in story and action, are to be considered as true works of dramatic art.

The mode, generally, of making these strong black-and-white effects is to have the figures and moving parts of separate units to be arranged under the camera in connection with a simple scene drawn in white, or gray, on a black ground. The figures of animals are made as dummies, with

jointed limbs. This makes it possible to put them into the various positions necessary for giving the illusion of life as they are moved about over the background.

These dummies are designed with but little detail and are drawn on a carefully selected white surfaced cardboard or thick paper that gives in contrast with the background good white-and-black negatives. The joinings of these figures or animals, are made with the thinnest kind of wire fashioned into tiny pivoting pins. Sometimes in spite of the artist's efforts to conceal these wire pivots by placing them where a hooked ink line indicates a fold of drapery, sharp-eyed individuals can detect them on the screen. Where such jointed dummies are used under the framed glass, the wire pivots will not do. Instead, the artist must find some way of fashioning cardboard rivets, or washers, to join the parts of the figures. A thin elastic tissue would do perhaps, as an expedient, to clothe these little dummies and hide the joinings of the cardboard segments.

Here we may note the so-called "trick" titles that are shown in theatres for special occasions, or in connection with the regular films. They

add with their liveliness a little variety to the tedium of a long presentation of monotonously toned photographs. In them, the letters make

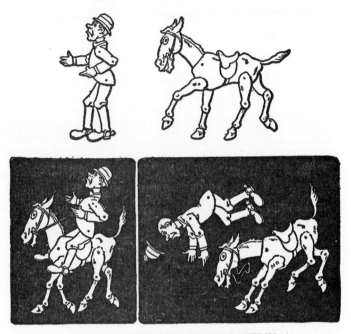

ARTICULATED CARDBOARD FIGURES.

their appearance one at a time, and in most cases they are white on a black ground. The production of these titles with their letters that merrily cut capers all over the background before they come into their orthographic order is a very simple

manœuvre. The separate letters, cut out of cardboard, are laid down to be photographed one at a time as they spell the words. Where they are first made to move about in an amusing manner, they are similarly manipulated on the background under the camera by being pushed about as desired and photographed at each change of position.

The best background for these titles, when it is to be solid black, is a piece of black velvet. This material is a serviceable article in motion-picture work as it gives an intense and certain black, and if wrinkles form in it they do not betray themselves by any lights or shadows in the photographic print.

Sometimes in trick work it is intended that some part of the design is masked while another part is being photographed. This is a simple matter if the background is a dark one, as a piece of paper, or cardboard, of the same color is placed over it while the photography is taking place. A line of letters, for instance, that is already drawn on the dark ground is to appear letter by letter. A strip of this dark-colored paper covers the words at first, but is pulled away to

expose the letters one by one. Another way would be to clip off a section of the paper bit by bit. Blackening the edges of the paper will provide against these edges showing as light lines and so giving away the ruse.

In selecting for working under the camera of dark-colored cardboards, it is advisable to pick out only those with dead mat surfaces and reject those with any enamelled or shiny surfaces.

As previously mentioned, for trick titles, a larger field is used than that for animated cartoons. It makes the manipulation of dummies and detached items much more convenient.

An amazing and wonderful screen illusion is that of animated sculpture. The audience first sees a shapeless mass of clay which of itself seems to assume in a few seconds a plastic composition. It is a portrait of a notable, perhaps, or it may take the form of a grotesque mask.

The trick of animated sculpture is produced like this: A camera is centred on a rough mass of clay, which is first photographed in this shapeless form. A sculptor now pushes the clay around to a desired preliminary effect, then when he has stepped out of the picture, that is, gets out of

the range of the lens, the clay is photographed again.　Once more the sculptor moulds the clay to a stage approaching the contemplated form, steps out of the picture and the camera brought into action again.

The proceeding is continued: modelling the clay, the sculptor getting out of the range of the lens, and the camera brought into action, until the clay has been fashioned in its complete form.　The interruptions during which the sculptor was working will not be represented on the screen as the camera was not working then, and so no exposures were made.　Instead, the effect will be a continuous one of a mass of clay miraculously forming itself into a plastic work.

The way of working in making animated sculpture, like that of the process of using dummies that are moved, little by little, while the shutter is closed and then photographed after each time that they have been moved, is called the "stop-motion" method.　The motion of the camera is stopped, in other words, while the particular object is placed in a new position each time before it is photographed.

When on the screen you see some thin black

line appearing on one side, crawling reptilian fashion, suddenly turning upward, twisting and soon beginning to outline the silhouette of a figure or part of a pictorial composition, there is exemplified another instance of this "stop-motion" photography.

This extraordinary performance of a plain line, to the average spectator seems wondrous, and its production a veritable mystery. But it is managed very easily.

For news picture reels it has been found judicious for variety's sake, as well as for business reasons, to combine with them cartoons satirizing topics of the hour. When they are wanted, they are wanted in a hurry, and as the regular type of cartoon takes not a little time to make, the living line drawings adverted to above, as they are quickly made, are often used for the purpose. We shall try to give in the following few paragraphs an elucidation of the method of making a film like this.

The general idea or composition of the drawing is sketched out first on a piece of ordinary paper, then its outlines are traced in blue markings to a sheet of Bristol board that has been fastened down

to the table beneath the camera within the photographic field. Light-blue marks do not take on the ordinary sensitized film. But the blue markings, it is to be remembered, must be of the faintest. The very cautious artist in beginning a work of this sort makes a preliminary test of his blue pencilling by photographing a short length of film and developing it to see if the marks show on the negative. If they show at all, it will be necessary to take a soft eraser and go over the drawing and make the blue marks less distinct, and only have them show enough to be able to follow the drawing in executing the pen work.

When quite sure that the blue marks will not photograph, the artist begins his drawing. It is not a difficult task that he has before him—he merely inks his previously drawn lines little by little. Each stroke of the pen, after it has been made, is photographed. If the ink lines are short the movement on the screen will be very slow, and if they are long the movement will be very rapid. And, again, whether the artist turns the camera handle once, twice, or three times for each pen stroke has its effect upon the speed with which the lines grow on the screen. If somewhat

long pen strokes are made and the exposure is but
one picture for each stroke the lines will run in
and finish the design at a rapid rate. On the
other hand, if they are very short strokes and

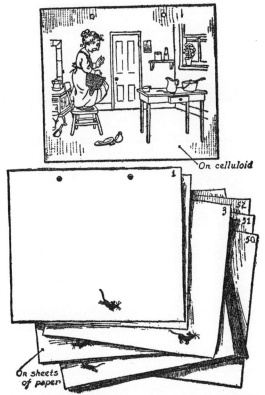

On celluloid

Or sheets
of paper

ILLUSTRATING THE ANIMATION OF A MOUSE AS HE RUNS
AROUND THE KITCHEN AND FRIGHTENS THE COOK.

The general scene is drawn on celluloid, while fifty or more sheets of paper
hold a sequence of pictures of the mouse in attitudes of running.

three pictures (about one-fifth of a foot of film) are given to each one, the lines will creep in on the screen at a snail's pace.

All this, making a line, a patch of tinting, a small detail of a picture, and photographing each item after it has been made, is continued until the entire pictorial design is completed.

Variety is produced by having the lines go slowly or fast according to the requirements of the idea to be expressed or the story to be told.

ON MOVEMENT IN THE HUMAN
FIGURE

CHAPTER V

ON MOVEMENT IN THE HUMAN FIGURE

HAVING now chronicled in a brief way the development of the cinematographic art, particularly in its relation to animated screen drawings, and having tried to give some notion of the fundamentals in their making with an account of their exhibition on the screen, it is in order now that we consider the matter of movement and its depiction by drawings that will give the visional synthesis of life.

The very first thing that a tyro in the animating art must learn is to draw a walk; or in other words, to become skilled in sketching the successive phases of limb and trunk movements so that they give in their order the appearance of walking when projected as a film.

Walking directly effected by the lower limbs calls into action the upper limbs too. The upper limbs act, as they swing from the shoulders, in concord with the legs, as counterpoises in main-

taining the equilibrium. An understanding of the principles underlying locomotion in man— walking or running—is an important matter to consider in this art. When an artist knows the basic facts of movement in the human figure, he will more readily comprehend animal locomotion and all other movements in general.

All forms of motion are pertinent as studies for the animator, and the all-important study is that of the human organism.

Although we observe at once, in considering a simple walking movement, that there is also a simultaneous activity of the arms accompanied by a harmony of exertion in the trunk, we will at the start dwell mainly upon the phases of action in the legs only.

Imagine now that the figure that is to serve us as a model is walking. The trunk in the air, some thirty inches above the ground, is moving forward. Attached to it are the nether limbs, alternately swinging pendently and alternately supporting the trunk in its position above the ground.

Further to simplify our study, we will, at first, consider the mechanism of one limb only. As

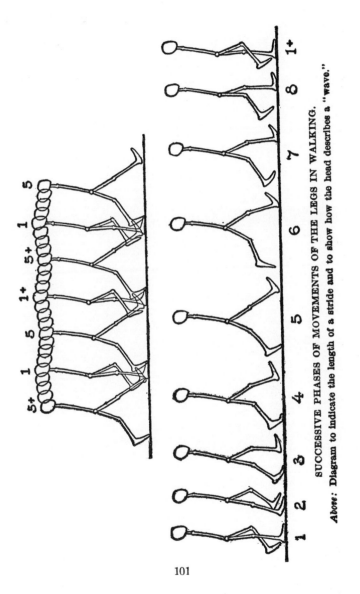

SUCCESSIVE PHASES OF MOVEMENTS OF THE LEGS IN WALKING.

Above: Diagram to indicate the length of a stride and to show how the head describes a "wave."

one foot swings forward and reaches a certain place, it seems to hesitate for an instant and then come down, heel first, on the ground. As the heel strikes, the body is slightly jarred and the oblique line of the limb, its axis, moves and approaches the vertical. In a moment, the limb is vertical as its supports the trunk and the sole of the foot bears on the ground. Then the axis of the leg changes its verticality and leans forward, carrying with it the body. Soon the heel leaves the ground and only the fore part of the foot—the region of the toes—remains on the ground. But before the foot is entirely lifted from the ground, there is a slight pause, almost immeasurable, coming immediately before the foot gives a push, leaves the ground, and projects the body forward.

During the time of the phases of movement described above, the foot, in a sort of way, rolls over the ground from heel to toes.

Immediately after the toes leave the ground, the knee bends slightly and the limb swings pendulum-like forward, then, as it nears the point directly under the centre of the trunk, it bends a little more and lifts the foot to clear the ground. After the limb has passed this central

point under the trunk and is beginning to advance, it straightens out ready to plant its heel on the ground again. When it has done so it has completed the step, and the limb repeats the series of movement phases again for the next step.

Now, the limb of the other side has gone through the same movements, too, but the cor-

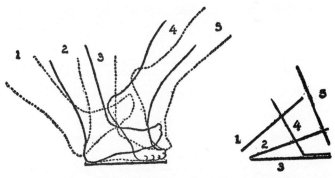

ILLUSTRATING THE ACTION OF THE FOOT IN ROLLING OVER THE GROUND.

responding phases occurred alternately in point of time.

One of these positions of the leg, that when it is bent at the knee so as to clear the ground as it passes from the back to its advancing movement forward, is rarely represented by the graphic

artist in his pictures. The aspect of the limbs when they are at their extremes—spread out— one forward and one to the back, is his usual pictorial symbol for walking. But the position, immediately noted above, is an important phase of movement, as it is during its continuance that the other limb is supporting the trunk.

A movement of the trunk in walking that is to be remarked is its turning from side to side as it swings in unison with the upper limbs while they alternately swing forward and backward. It is a movement that animators do not always regard, since only an accomplished figure drafts- man can imagine movement clearly enough to reproduce it. To describe the movement better we will consider it visionally.

We are looking at the walker from the side and see the trunk in profile—exactly in profile, of course, when the arms are at the middle posi- tion. As the near-side arm moves forward we see a slight three-quarter back view of the upper part of the trunk, then when the arm swings back we see the profile again, and with the arm moving still farther back, the corresponding side of the shoulder moves with it and the upper part of

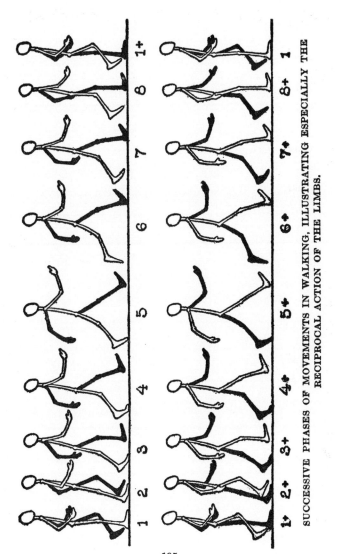

SUCCESSIVE PHASES OF MOVEMENTS IN WALKING, ILLUSTRATING ESPECIALLY THE RECIPROCAL ACTION OF THE LIMBS.

105

the trunk is seen in three-quarter front view. If the artist shows, in a walk, these particulars: (1) A three-quarter view from the front; (2) profile; (3) a three-quarter view from the back, and then carries them back and forth, he will add to the effectiveness of the screen representation. It gives to a figure, when slightly exaggerated in a humorous picture, a very laughable swaggering gait.

The arms were mentioned as swinging in a walk so as to help maintain the equilibrium. It will not be difficult to understand the phases through which they go if it is remembered that an arm moves in unison with the lower limb of the opposite side. This can be observed if one looks from an upper window down on the passers-by. It will then be noted how one arm as it hinges and oscillates from the shoulder-joint, follows the lower limb of the opposite side as it hinges and swings from the hip-joint.

Contemplating the arms only, it will be perceived that they keep up a constant alternate swinging back and forth. The point where they pass each other will be when they both have approached their respective sides of the trunk. This

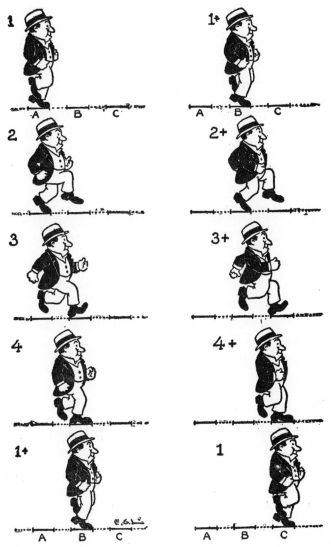

PHASES OF MOVEMENT OF A QUICK WALK.

Four phases complete a step.

107

particular moment when the arms are opposite one another and close to the trunk, or at least near the vertical line of the body, is coincident with the phases of the lower limb movements when one is nearly rigid as it supports the body and the other is at its median phase of the swinging movement.

These middle positions of the four limbs—the lower near to each other, and the upper close to the body—is a characteristic that should be taken note of by the artist. It illustrates, in connection with the extreme positions, certain peculiarities of motion in living things, in general. This is a sort of opening movement following by a closing one. These reciprocal changes, expansion and retraction in organic forms, symbolize the activity of life.

In the human body, for instance, during action, there are certain times when the limbs are close to the trunk and at other times when they are stretched out or extended. This is adequately made plain in jumping. Specifically: in the preliminary position before the actual jump, the appendicular members bend and lie close to the trunk. The entire body is compact and repressed

like a spring. Then when the jump takes place, there is a sudden opening as the limbs fling themselves outward.

A rower in a shell plying his sculls exemplifies this phenomenon of a spring-like closing and expansion. In this case there is also a typical

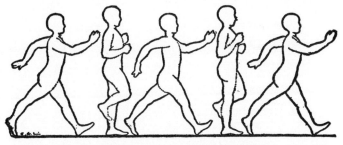

A SUCCESSION OF ALTERNATE CONTRACTIONS AND EXPANSIONS CHARACTERIZES MOTION.

example of reciprocal compensating movements in the two pairs of limbs. When the rower leans forward and the arms are extended ready to pull on his sculls, the lower limbs are flexed and in contact with the front of his trunk. Then when the sculls have been pulled back and he has reached the other extreme position, the arms are flexed and close to his chest, while the lower limbs are stretched out straight.

If the animator is planning to walk a figure

across the field of the screen, there is one matter in the representation that he punctiliously takes heed of. It is this: to have the trunk rise as it is in turn supported upon one rigid leg and then upon the other, and to show that it falls slightly when the two limbs are outstretched at their extreme positions. In this alternating rise and fall of the trunk in walking, the head can be observed as describing a wave. The highest point of the wave is when the trunk is supported on the rigid leg and the lowest point when both limbs are stretched out as if flying from the vertical of the body.

(*For the following few paragraphs, see illustrations on pages* 112 *and* 113.)

In scheming out the positions for a walk, the artist first draws one of the extreme outstretched positions (*A*). (It is supposed that we are drawing a figure that is going from left to right.) Then on another sheet of paper the following outstretched position (*B*), but placed one step in advance. These drawings are now placed over the tracing glass of the drawing-board. All the following drawings of this walk are to be traced over this glass, and they will be kept in register

by the two pegs in the board. As now placed, the two drawings (*A* and *B*) cover the distance of two steps. A foot that is about to fall on the ground and one that is about to leave it meet at a central point. Here a mark is made to indicate a footprint. A similar mark for a footprint is made on each side to indicate the limits of the two steps.

A sheet of paper is next placed over the two drawings (*A* and *B*), and on the central footprint the middle position (*C*) of the legs is drawn. In this the right limb is nearly straight and supporting the body, while the other limb, the left, is bent at the knee and has the foot raised to clear the ground. The next stage will be to make the first in-between position (*D*) between the first extreme and the middle position. It is made on a fresh sheet of paper placed over those containing the positions just mentioned. The attitude of the right limb in this new position would be that in which it is about to plant its foot on the ground and the left limb is depicted as if ready to swing into the position that it has in the middle one (*C*).

Then with the middle position (*C*) and the last extreme one (*B*) over the glass, on another

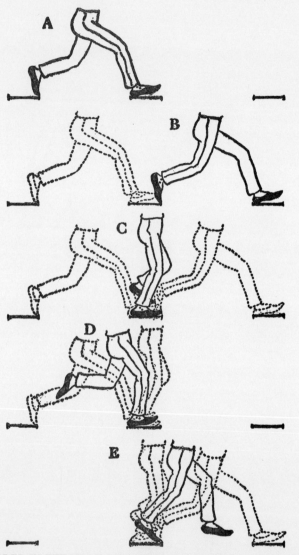

ORDER IN WHICH AN ANIMATOR MAKES THE SEQUENCE OF
POSITIONS FOR A WALK.

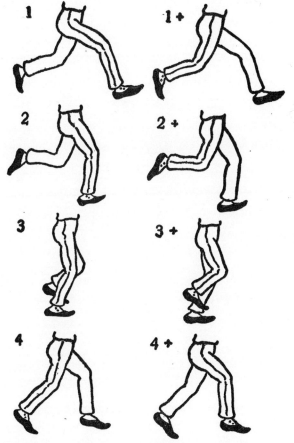

Illustrating how alternating series of positions are the same in outline, differing only with respect to whether the near or the far limb is moving forward.

sheet of paper, the next in-between one (*E*) is drawn. This shows the right foot leaving the ground and the left leg somewhat forward ready to plant its heel on the ground. We have now secured five phases or positions of a walking movement.

The two extremes (*A* and *B*) spoken of as the outstretched ones have the same contours but differ in that in one the right limb is forward, and the left is directed obliquely backward, while in the other it is the left limb that projects forward and the right has an obliquity backward.

Now, if we make tracings, copying the outlines only, of the three other positions (*C*, *D*, and *E*), but reversing the particular aspects of the right and the left limbs, we shall have obtained enough drawings to complete two steps of a walk.

As a better understanding of the preceding the fact should be grasped that while one limb, the right we will say, is assuming a certain position during a step, in the next step it is the turn of the other limb, the left, to assume this particular position. And again in this second step, the right limb takes the corresponding position that the other limb had in the first step. There are always, in a

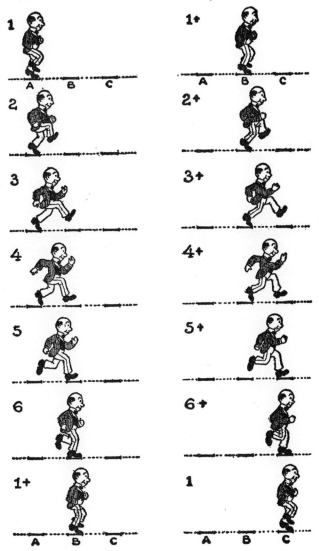

PHASES OF MOVEMENT OF A WALK.

Six phases complete a step.

115

walk, two sets of drawings, used alternately. Any particular silhouette in one set has its identical silhouette in the other set, but the attitudes of the limbs are reversed. To explain by an example: In the drawing of one middle position, the right leg supports the body and the left is flexed, in its coincidental drawing, it is the left that supports the body and the right is flexed. (See 2 and 3+, of engraving on page 113.)

From this it can be seen that the two sets of drawings differ only in the details within their general contours. These details will be such markings as drapery folds, stripes on trousers, indications of the right and the left foot by little items like buttons on boots. Heeding and taking the trouble to mark little details like these add to the value of a screen image.

One of the most difficult actions to depict in this art is that which the animator calls a perspective walk. By this term he means a walk in which the figure is either coming diagonally, more or less, toward the front of the picture or going away from it toward the horizon. It is obvious that according to the rules of perspective, in coming forward the figure gets larger and

larger, and in travelling in the opposite direction it gets smaller and smaller. To do this success-fully is not easy. Only after a worker has had a great deal of experience in the art is he able to draw such a movement easily.

The constant changing sizes of the figures and getting them within the perspective lines in a graduated series are perplexing enough matters. But this is not all. There is the problem of the foreshortened views as the limbs are beheld per-spectively. Imagine, for instance, an arm point-ing toward the spectator in a foreshortened view. Every artist would have his own individual way

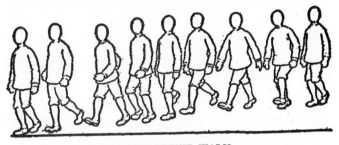

A PERSPECTIVE WALK.

of drawing this. Those with a natural feeling for form and understanding anatomy solve prob-lems of this kind by methods for which it is im-possible to give any recipe. Some would start

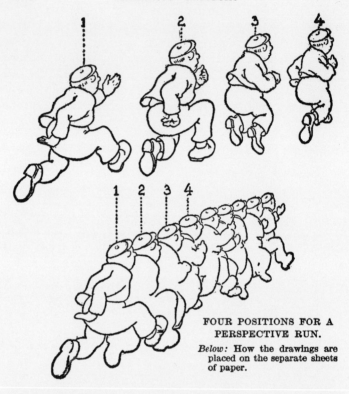

FOUR POSITIONS FOR A
PERSPECTIVE RUN.

Below: How the drawings are
placed on the separate sheets
of paper.

with preliminary construction lines that have
the appearance of columnar solids in perspective,
while others scribble and fumble around until
they find the outlines that they want.

Happily in most of the occasions when a per-
spective walk is required in a story it is for some
humorous incident. This signifies that it can be

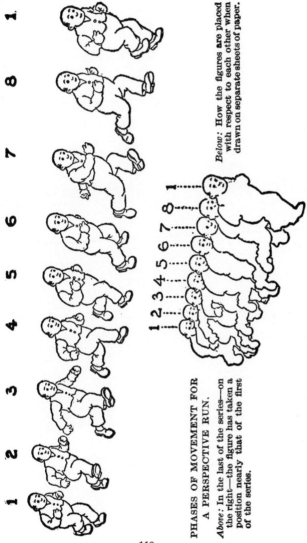

1 2 3 4 5 6 7 8 1.

PHASES OF MOVEMENT FOR
A PERSPECTIVE RUN.

Above: In the last of the series—on
the right—the figure has taken a
position nearly that of the first
of the series.

Below: How the figures are placed
with respect to each other when
drawn on separate sheets of paper.

119

made into a speedy action, and that but a few drawings are needed to complete a step.

Artists when they begin to make drawings for screen pictures find a new interest in studying movement. In the study of art the student gives some attention, of course, to this question of movement. Usually, though, the study is not discriminating, nor thorough. But to become skilled in animating involves a thoughtful and analytic inquiry into the subject. If the artist is a real student of the subject its consideration will be more engrossing than the more or less slight study given to the planning of the single isolated phases, or attitudes, of action in ordinary pictorial work.

A great help in comprehending the nature of movement and grasping the character of the attitudes of active figures are the so-called "analysis of motion" screen pictures. In these the model, generally a muscular person going through the motions of some gymnastic or athletic activity, is shown moving very much slower than the movement is in actuality. This is effected by taking the pictures with a camera so constructed that it moves its mechanism many times faster than the normal speed.

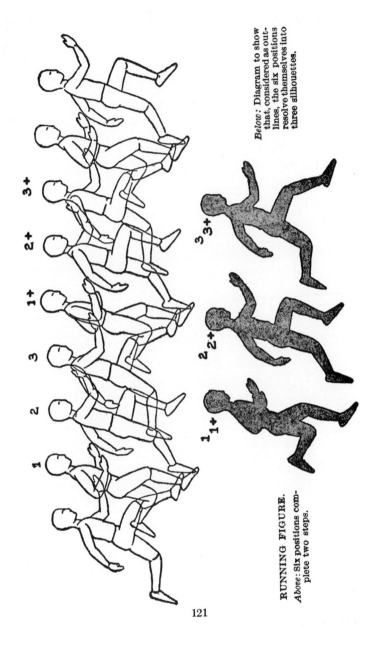

RUNNING FIGURE.

Above: Six positions complete two steps.

Below: Diagram to show that, considered as outlines, the six positions resolve themselves into three silhouettes.

121

The speed of the ordinary camera, as we know, moves during every second but one foot of film and on which sixteen separate photographs are made. Now, in one type of camera for analysis of motion photography, eight times more film is moved with a corresponding increase in the number of separate pictures taken on it during this same time of one second. To take a specific movement of a model lasting one second: the ordinary camera catches sixteen phases of it, but the extra-rapid camera takes about one hundred and twenty-eight separate pictures of as many corresponding separate phases. In other words, the ordinary camera takes about as much as our eyes appreciate, while the fast camera records on a length of film many more attitudes during the course of the given activity than the unaided eye can ever hope to see. When this long film of the extra-rapid camera is run through the projecting machine at the normal speed it shows us on the screen, in a period of eight seconds, that which took place in reality in but one second.

The animated drawing artist becomes, through the training of his eye to quick observation and the studying of films of the nature immediately

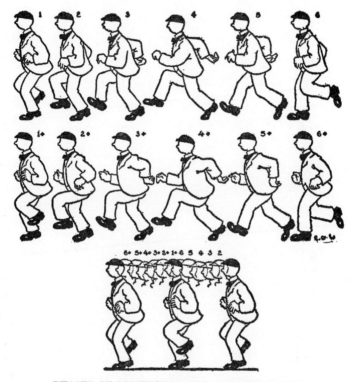

PHASES OF MOVEMENT FOR A QUICK WALK.

Lower diagram shows how the several drawings, each on a separate sheet of paper, are placed in advance of each other.

noted above, an expert in depicting the varied and connected attitudes of figures in action. Examples for study on account of the clear-cut definitions of the actions, are the acrobats with their tumbling and the clowns with their antics.

Then in the performances of the jugglers and in the pranks of the knock-about comedians, the animator finds much to spur him on to creative imagery. The pictorial artist for graphic or easel work, in any of these cases, intending to make an illustration, is content with some representative position that he can grasp visually, or, which is more likely to be the case, the one that is easiest for him to draw. But the animator must have sharp and quickly observing eyes and be able

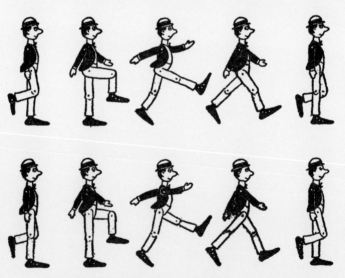

WALKING MOVEMENTS, SOMEWHAT MECHANICAL.
Suitable for a droll theme.

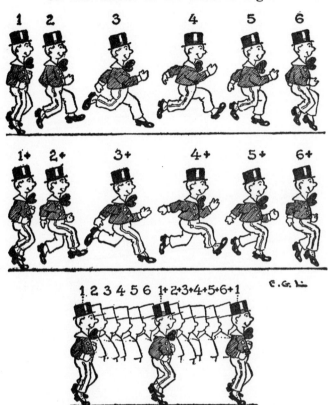

PHASES OF MOVEMENT FOR A LIVELY WALK.

Lower diagram shows how the drawings, on separate sheets of paper, are placed with respect to each other to continue the figure across the scene.

to comprehend and remember the whole series of phases of a movement.

A fancy dancer, especially, is a rich study. To follow the dancer with his supple joints bending

so easily and assuming unexpected poses of body and limbs, requires attentive eyes and a lively mental photography. The limbs do not seem to bend merely at the articulations and there seems to be a most unnatural twisting of arms, lower limbs, and trunk. But it is all natural. It simply means that there is co-ordination of movement in all parts of the jointed skeletal frame. This co-ordination—and reciprocal action—follows definite laws of motion, and it is the business of the animator to grasp their signification. It is, in the main, the matter already spoken of above; namely, the alternate action of flexion or a closing, and that of extension or an opening.

With these characteristics there is also observable in the generality of dancing posturing a tendency of an upper limb to follow a lower limb of the opposite side as in the cases of walking and running.

Very strongly is this to be noticed in the nimbleness of an eccentric dancer as he cuts bizarre figures and falls into exaggerated poses. For instance, when a lower limb swings in any particular direction, the opposite arm oscillates in the same direction and brings its hand close

enough to touch this concurrently swinging lower limb.

This symbolical phenomenon of the activity of living things—the negative quality of a closing

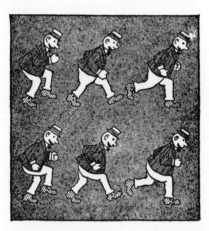

PHASES OF MOVEMENT FOR A QUICK WALK.

or flexion, and the positive one of an opening or extension—is not a feature entirely confined to human beings and animals, but is a characteristic showing in the mechanics of many non-living things.

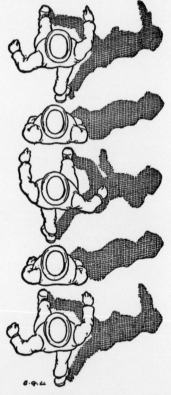

WALKING MOVEMENT VIEWED FROM ABOVE.

Illustrating how the diagonally opposite limbs move in unison.

NOTES ON ANIMAL LOCOMOTION

CHAPTER VI

NOTES ON ANIMAL LOCOMOTION

IN the usual manner of locomotory progress in the four-footed beasts, with but a few exceptions, the actions of the limbs with respect to the reciprocal movement of the two pairs, is the same as that of man. When, for instance, a fore limb moves, corresponding to the human arm, the diagonally opposite hind limb, corresponding to the human lower limb, moves also.

To explain this matter, again, we shall find it helpful to give a somewhat humorous, but at the same time a very practical example. An artist intends to draw the picture of a man crawling on his hands and knees. Before beginning to work, the artist will visualize the movement if he can, if not, try it by personal experiment. Then he will see that when the right hand, we will say, is lifted to go forward, immediately the left knee leaves the floor and the two limbs—the right arm and the left leg—advance at the same time.

On the completion of this advancing action, the hand and the knee touch the floor nearly at the same instant. (Exactly, though, the hand is carried forward more rapidly and anticipates the knee in reaching the floor.) After this action, which has just been described, is concluded, it is the turn of the other arm and leg to go through the same movements. This is the manner, in a general way, that the four-footed animals walk, successively moving together the diagonally opposite limbs.

An understanding of this locomotory principle— the reciprocal actions of the two pairs of limbs— in the generality of quadrupeds, will help an artist to animate the various types of animals that he will from time to time wish to put into his cartoons. Naturally, they will be in most cases combined with a comical screen story. Their depiction, then, can be represented in a humorous way and the artist merely needs to show in his drawings the essentials of animal locomotion.

Instantaneous photographs of moving animals, especially those of Muybridge, are helpful in studying the movements of the dumb creatures. The mindful examination of such photographs

gives hints as to the particular phases of movement adaptable to animation.

Besides photographs, an ingenious auxiliary, as a help in study, would be a little cardboard jointed model of an animal. Say it is one to represent a horse, it can be employed by moving the limbs about in their order as they successively make the steps while the artist selects from a series of photographs a cycle of positions for a movement. In making a jointed cut-out model, however, and fastening the limbs by pivoting pins, it is well to remember that the model can be approximate only. Take the fore limbs, for instance. In your model you will probably fasten them to the trunk at some fixed place. That is not the way that they are joined in the bony framework. The joining of the fore limbs is not by a hard articulation as in the arms of man which are joined, through the intermediary collar-bone, to the breast-bone. In the horse and in quadrupeds, generally, the joining to the main bulk of the body is by soft tissues. That is, by layers and bands of muscle.

In studying the actions of animals it will be observed, especially in the antelope and deer

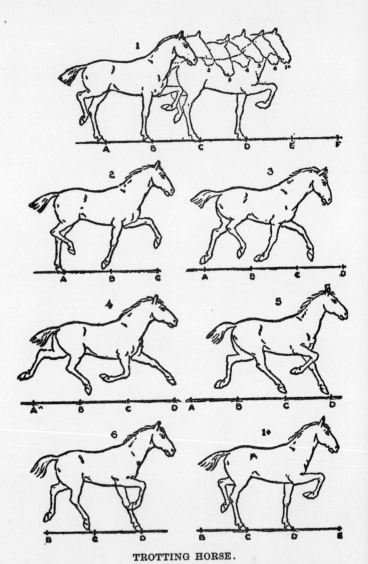

TROTTING HORSE.

The horse in the first series moves from *A B* to *C D*. The drawings in the second series, on the next page, with plus marks are the same in silhouette as the correspondingly numbered ones of the first series.

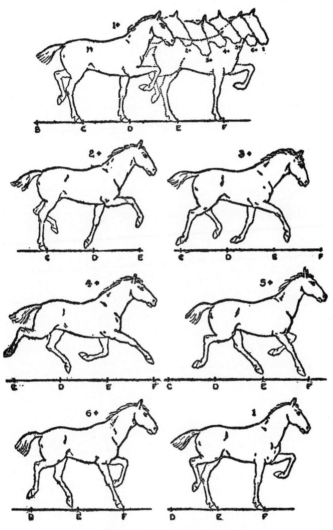

TROTTING HORSE (continued).

In the second series the horse moves from *C D* to *E F*, where he takes the same attitude as that of number 1 of the first series.

135

kind, that in leaping they land on their forefeet. Any hard articulations of the fore limbs with the rest of the skeleton could not submit to the shock of these landings. When they land, it is the soft yielding and elastic muscular parts of the shoulders and adjacent regions that absorb the force of the jolts.

The characteristic of life activity, flexion and extension, is exemplified clearly in the actions of an animal's hind limbs as they double up in the preparation for a leap; and then suddenly spread out during the first part of the leap.

Taking it as a whole, in fleet-footed animals, the function of the hind limbs is to furnish the forward propelling force while that of the fore limbs is to land on the ground at an advanced position. This observation, of course, applies to certain rapid methods of progression, and it will do as a general statement only, as it has been shown by photographs that the fore limbs have a share in giving an impulse in locomotion. For example, photographs o fthe horse in action show the quick springing action of the fetlock and the pastern joints as they bend in the hoof's impact, and its subsequent extension when the foot leaves the ground.

In a rapid walk of a horse a phase of movement that is apprehended by the eye is the lifting of a forefoot and then the immediate impact of the hind-limb of the same side as it nearly falls into the impression left by the fore foot. There are speeds in which the footprints coincide. In a more rapid pace than a walk, the imprint of the hind foot is farther forward than that of the forefoot. As the speed increases the stride lengthens and the footprints are much farther in advance.

In a certain type of humorous animation—the panorama—to be explained in a succeeding chapter, the artist is quite satisfied with his animation of a quadruped if a lively bewildering effect of agitated limbs is produced on the screen. This bewildering blur has after all a resemblance to that which the eye sees in rapidly running animals; namely, a confused disturbance of limbs. This effect on the screen always causes laughter and the artist considers that as a proof of the success of his work.

To produce this effect, the animator selects from his studies three or five consecutive positions of a gallop, or trot, that will animate well. This means, specifically, that any particular drawing

should, with the next in order, give an appearance of movement when they are synthesized. The drawings are made in a cycle so that when

A PANORAMA EFFECT OBTAINED BY THE USE OF THE
THREE DRAWINGS ON THE OPPOSITE PAGE.

used continuously in their order they will give the illusion desired.

In a panorama it is not necessary to trouble about a matter that in other forms of screen representation of locomotion are highly important. This is to have the feet register, by which is meant that in any several succeeding drawings

where a foot is represented as touching, bearing down, and leaving the ground, it should do all this on a footprint that coincides in all of the series. Tracing over the illuminated glass, while making the drawings, is the only way to get footprints accurately placed.

The droll-looking giraffe, with his awkwardly

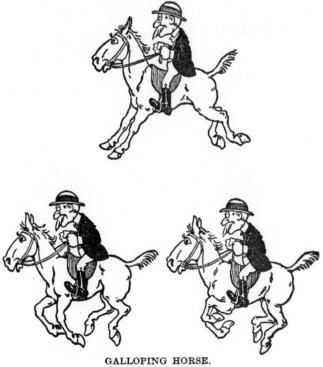

GALLOPING HORSE.
Three phases of the action for panorama effects.

set limbs, has a different sort of movement, in some of his paces, from that .remarked as natural to quadrupeds. In the giraffe, the two limbs of the same side move at the same time and in the same direction. The camel is also noted as going this way, and the elephant has a pace that seems to be a combination of the amble and the typical four-footed way of walking.

Now and then the animator has as one of his char-

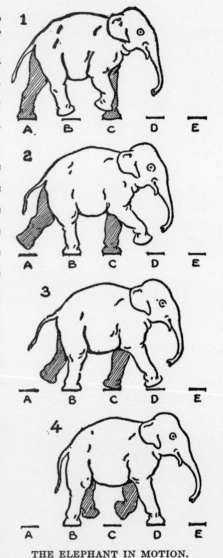

THE ELEPHANT IN MOTION.

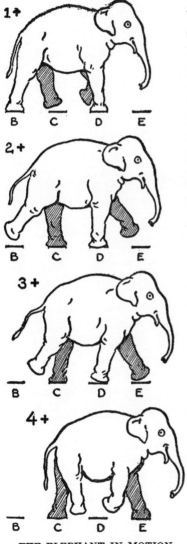

THE ELEPHANT IN MOTION
(continued).

acters a walking bird; an ungainly ostrich is a good example, or a droll duck, perhaps. Here he will have plenty of scope in applying his skill as a humorous draftsman. A nodding of the head and a bobbing of the body from side to side in the duck, and in the case of the ostrich a wiggling of the neck, are appropriate adjuncts to such animation.

In the walking movement of a bird the method of getting the different phases will be the same as that of planning a walk for the human figure. Particularly, too, must

the artist observe in the bird's walk, the middle phases in which one leg crosses the vertical of the body to go forward for the implanting of its foot upon the ground.

With respect to the study of wing movement in flying birds, it is interesting to note that the Japanese artist apprehended the various positions that wings took in flying before the fact was demonstrated by photography. The Occidental artist, before the days of the instantaneous snapshot camera, had but one or two stereotyped positions for picturing flying birds. Generally one of these positions had the wings pointing upward, and another with them outspread, more or less, horizontally. But the Japanese artist anticipated the snap-shot picture; he often had his flying birds with the wings drawn below the level of the bird's body and pointing downward.

One good way, if an animator wishes to represent a bird flying across the sky, is to have several—five or seven—positions for the action drawn on cardboard and then cut out. These little bird models are placed, one at a time, over the general scene during the photography and manipulated in the same way as described for

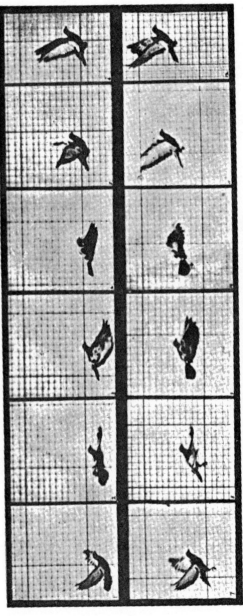

PIGEON IN FLIGHT.

Note the positions with the wings pointing downward. These are phases of wing movement anticipated by the Japanese artist before their existence was clearly shown by instantaneous photography.

Part of a plate in Muybridge's "Animals in Motion." Copyright, 1899, by Eadweard Muybridge. London, Chapman & Hall, Ltd. New York, Charles Scribner's Sons. A valuable work for the artist in studying movement in animals.

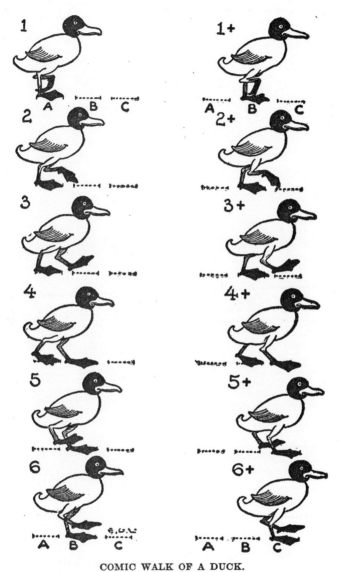

COMIC WALK OF A DUCK.

Series of drawings required to move the bird from *A* to *C*.

143

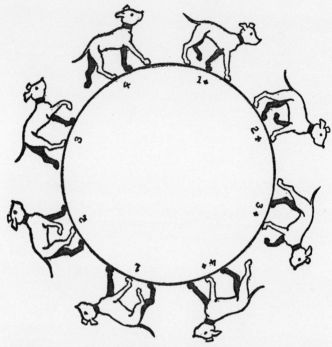

CYCLE OF PHASES OF A WALKING DOG ARRANGED FOR THE
PHENAKISTOSCOPE.

other cut-out models. The slight wavering from
the direct line of the bird's flight that may occur
by this cut-out method would not matter very
much. The bird describes a wavering line any-
way as he flies—its body dropping slightly when
the wings go up and a correlative rise occurring
when the wing flap takes place.

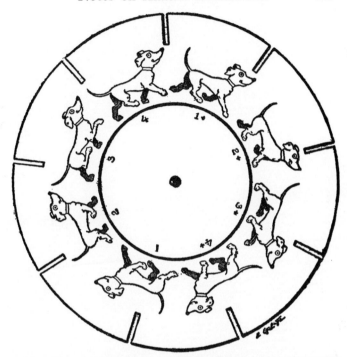

PHENAKISTOSCOPE WITH A CYCLE OF DRAWINGS TO SHOW
A DOG IN MOVEMENT.

If an artist wishes scrupulously to be exact
in drawing a bird flying across the sky, he should
observe certain rules of perspective applying to
the case. The problem is the same as that of
the airplane, previously noted, which flew across
the field of the picture. Regarding this matter,
to specify: When the bird appears on one side

it is represented in a side view, which changes as it gets near the centre to a profile. After it has been viewed in profile, the perspective changes again and when it reaches the other side it is again in a perspective side view, slightly from the back.

In the mode of progression that was given as the usual one in quadrupeds, in which a diagonally opposite fore and hind limb moved simultaneously, there is a sinuous lateral twisting of the back-bone. It is not so perceptible to us in the larger beasts. It is an effect, though, that takes place in other creatures and in some of them can be clearly seen. In the walk of the lizard, as an instance, when viewed from above, a successive undulation of the back-bone takes place. As one fore limb— the right, to particularize—moves forward, that side of his body—the right shoulder, moves forward, too; while approximately at the same time the left hind limb moves forward and carries with it that side or the left pelvic regions. This causes an alternating obliquity of the transverse axes of the shoulder and the hind regions of the body of the reptile as he walks on the ground. And this alternate changing of these axes gives rise to a continuing sinuosity in the spine.

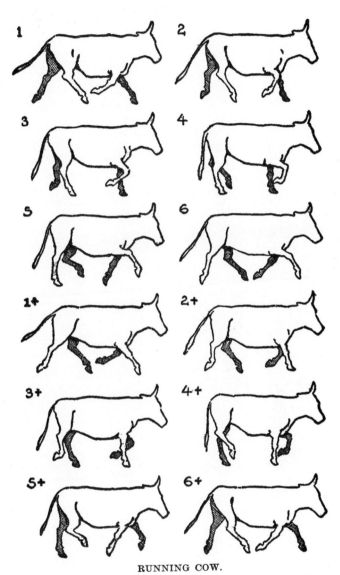

RUNNING COW.

Positions selected and adapted from Muybridge's photographs.

147

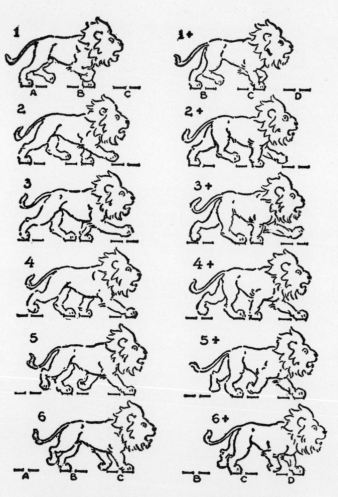

PHASES OF MOVEMENT OF A WALKING LION.

148

The mode of progression in legless creatures is distinguished, too, by a lateral bending in and out. Snakes and eels, for example, as they pro-

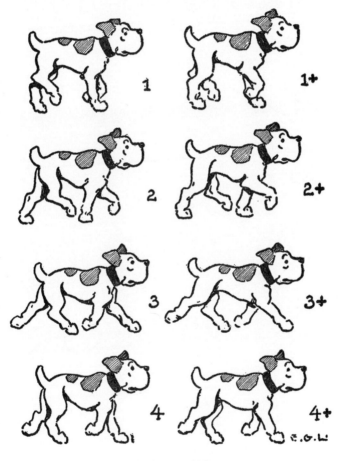

DOG WALKING.

ceed agitate their bodies in wave-like motions.
The waves pass from the head to the tail, the
fluctuations taking the form of rather large loop-
like wrigglings of the elongated body. A spring-
like coiling up and then an expanding—flexion
and extension again—is the principle of the loco-
motory manœuvre in the snake.

The undulatory motive impulse of a creeping
animal is somewhat like the sudden lashing of a
whip, or the wave-like disturbance given to a
rope when it is sharply and strongly shaken in a
certain way.

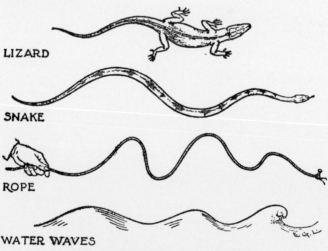

LIZARD

SNAKE

ROPE

WATER WAVES

VARIOUS KINDS OF WAVE MOTION.

A characteristic of many forms of movement which the animator gets in
certain of his delineations.

INANIMATE THINGS IN MOVEMENT

CHAPTER VII

INANIMATE THINGS IN MOVEMENT

THERE is very little effect of motion on the screen of a moving straight line by itself without any contrasting elements. Or, as the moving-picture draftsman would say, it does not animate well.

Now supposing a picture is intended of a man tugging at a rope. He pulls hard and the rope is taut and it appears practically straight. The animation of the arms shows that they are moving and give a good illusion of the tugging, but the rope shows no movement on account of its rectilinearity. It will be only when the artist gives the rope a little undulating—or even a snake-like —motion now and then that he can give the effect of any disturbance in it. This sort of thing, a slight shaking or a wavering of the line, would do for ordinary cases but it would be better if the artist showed a loose strand of cordage fibre creeping along in the direction that the

153

rope is supposed to be going. But still better would it be to have a few kinks forming in the rope and showing them agitated as they go in the direction of the pull on the rope. In producing this latter illusion the likely expedient that the skilled animator would use is that of having a set of celluloids with drawings—three or five—showing the kink represented in a number of progressive positions. The plan would be to have the details in a cycle, so that when the last detail of the cycle is photographed, the first one exactly follows in a proper order. The artist can put these rope drawings on the same sheets of paper that hold the arm movements—we have in mind the picture of the man tugging at the rope, of course. Then the cycle of drawings with the arm movements and the kinks of the rope in their progressive order can be used over and over again as long as it seems consistent with good judgment.

This idea of arranging things in cycles is the general way of animating inanimate things. Nearly all the technical items in this chapter are managed with some such plan. Generally, too, the details are drawn on the transparent celluloids.

The problem in devising the components of any cycle is to have these components so arranged that the orderly movements take place from the first of the series to the last and then begin with the first again. The action must not skip, cause a hesitation, or go backward. This simply means that the components are to be spaced properly with respect to their relations to each other.

It would be difficult to give by words any directions exactly how to do this; actual drawing, with a testing in the preliminary sketches is the surest way of accomplishing it. As general directions, however, the advice would be to have an odd number of drawings and to vary the spatial intervals between the separate items. They should not, above all things, be equidistant.

Where the artist wishes to present to the spectator an animated drawing of a waving banner, or flag, he makes a cycle of different drawings. If it is a flag, these drawings are made with undulating folds that pass the length of the flag as if it were agitated by the wind. Almost any sort of rippling effect, necessitating but three slightly different drawings, will satisfy the average audience. But if the artist wishes to do con-

scientious work, he will give a little more attention to his planning and try to make it nearer actuality. Then he will contrive that there be one dominant drapery fold which is carried out farther and farther along the ruffled flag. As this fold nears the end it lessens its volume and at last disappears in a sudden flap. This will take five or seven drawings. In planning the cycle it will be arranged that immediately before the last flapping, the first phase of the dominant fold begins again.

This effect of ruffling drapery by a fixed set of cycles used always in the same order will, of course, give a monotonous waving. But it can be diversified by an occasional break in the order in which the separate elements of the cycle are photographed, or an added modification obtained by a supplemental large flapping fold which can be produced by one extra drawing.

An ordinary fragment of drapery in a garment is easily animated by making it in three phases. This will give a satisfactory quivering motion when projected in any bit of drapery that is blown about or flutters on a figure in action.

Flowing water, waves, and rippling on the

An Early
American
Flag

CYCLE OF DRAWINGS TO PRODUCE A SCREEN ANIMATION
OF A WAVING FLAG.

surface of a stream, are not difficult matters to animate if the artist keeps in mind that the plainest unelaborated line work gives for these elusive pictorial ingredients the most striking effects on the screen.

It is customary, again, for artistic particulars like these to be made in cycles of three or five drawings. The action for this class of subjects is nearly always quick, and so drawings for the purpose need not be numerous.

A water-splash is a detail of a screen animation rather frequently introduced. Animators have adopted a stereotyped way of rendering it. When it is associated with a falling of some unlucky character into the water, it is very effective from a pictorial and a humorous point of view. The succeeding up-rushing column of water, after the splash, is made in the form of a huge mushroom— rather conventional but extremely comical.

In such a particular as a jet of water, a cycle of drawings is also used. In planning such drawings for animation care must be taken that they give in the combined screen illusion a proper one of falling water. The slightest misplacing of succeeding details representing the jet may give an

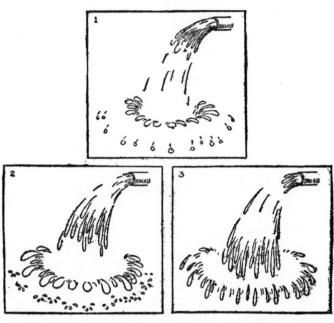

CYCLE OF DRAWINGS FOR AN EFFECT OF FALLING WATER.
The drawings are repeated, number 1 following number 3.

effect of the water going backward. A funny touch is what is wanted in a humorous picture, but, generally, not of this sort.

Imparting an appearance of rain over a scene is produced by having several celluloids with lines indicating this. They would be used in their order as designed during the photography in the usual way.

Falling snow—that indispensable ingredient of the provincial melodrama—is simply managed by spreading, at haphazard over several celluloids, spots of white pigment. A general tinting, of course, over the underlying pictorial composition would add, by contrast of tone, to the illusion.

A blank sheet of celluloid placed over the entire drawing is often employed to hold components of some quickly moving element of an incident. Each separate detail of its drawing, in this case, is made on this blank celluloid under the camera and photographed as it is made. Supposing that it is lightning zigzagging across a dark background. There will be drawn over this celluloid the first part of the bolt, photographed and then another part drawn which is photographed, and then the end of the bolt which is also separately taken. This drawing of the lightning-bolt, in white pigment, can be easily rubbed off with a paint rag, or cotton wadding, and then another lightning-bolt drawn and photographed in the same way.

In some cases where a large volume of smoke is to be shown in hurried movement, the animator draws the smoke in distemper pigment—sombre dark grays, half-tints, or in white—on a blank

sheet of celluloid covering the scene. The effect of smoke moving very quickly could also be drawn in progressive fragments on the upper surface of the glass in the frame that is pressed down upon the drawings each time that they are photographed. If it is a house burning, for instance, the flames in white paint and the smoke in grays and black can be put on its surface.

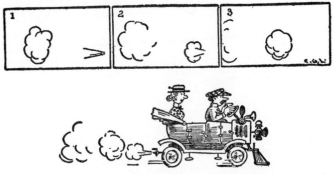

A cycle of three drawings is sufficient to give a vivid representation of the puffing exhaust from an automobile.

Little happenings that form part of a general scene are managed, as a rule, too, by cycles of drawings or cycles of details in a drawing. To specify a few things, we may cite puffs of vapor from an automobile, steam pouring out of the spout of a teakettle, and smoke from a chimney.

Vapor, steam, and smoke are best represented by pigment, as hard ink contours are not exactly suited for such elements of a pictorial composition. But such elements defined by ink lines in a comic drawing are, of course, excusable. Sometimes to show smoke moving where the drawings are all on paper, representing it by crayon-sauce with a stump has been found to be effective.

If an artist is picturing in a comic cartoon the firing of a cannon, he indicates a globular projectile leaving the cannon's mouth. The artist does not do this because of any scrupulous care in picturing reality but merely that it seems in keeping with the idea of vivid comic delineation.

In producing the appearance of a cannon-ball following its trajectory off into the far distance he takes heed of the law of perspective that requires an object to become visionally smaller as it nears the horizon. This animation is easily

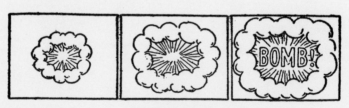

AN EXPLOSION.

managed. A certain number of models of the missile are cut out of thin cardboard graduated in size from the first that leaves the cannon's mouth to the smallest for the distance. They are used by putting one at a time in their proportionate places under the camera in connection with the other work during the photography. Not many of these models would be required, as the action is so rapidly represented that almost any sort of illusive effect will do for the purpose.

According to the popular idea, every comic scenario should provide for some cataclysmic climax in which the entire picture area, or a large part of it, is to be filled with the graphic symbols denoting an explosion or any sudden occurrence or mishap. Such things for the animator are not hard.

Then radiating lines, exclamation-points, zigzagging lines, and similar whimsical markings—

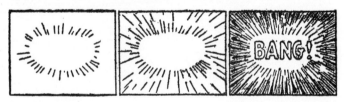

THE FINISHING STROKE OF SOME FARCICAL SITUATION.

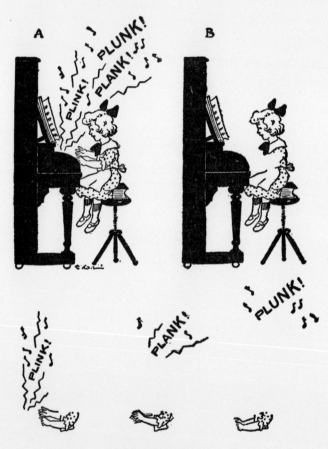

PIANO PRACTICE.

A. General effect of the animation.
B. Part of the design which is drawn on the transparent celluloid.
Below: Three separate drawings, used in sequence, with the design on
the stationary celluloid.

shorthand signs emphasizing the comic note—are
ideographs of expression that the animator de-
lights to put into his work. Besides their forcible-
ness, they add variety to the film.

But bits of dramatic business like these should

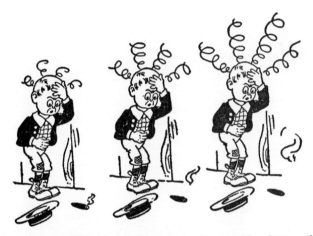

These three drawings are used in sequence and repeated as long as the
particular effect that they give is desired.

be used in moderation and in their proper places
and always at the right time. Besides, being
easily drawn, their accomplishment on the film
presents no difficulties.

The several methods by which they can be
produced are: (1) To arrange their components

in cycles; (2) drawing them in their order under
the camera and photographing progressively;
(3) have little cut-out pieces to move about under
the camera and photographed at each place that
they have been moved to.

Take for instance such a nonsensical conceit

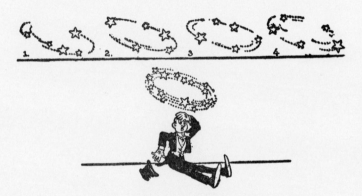

A CONSTELLATION.

The four simple elements above give on the screen the lively animation
indicated by the lower sketch.

as that of having a constellation of stars encircling
a dazed man's head. This could be made by
having (1) a cycle of drawings for the effect; or
(2) drawing it progressively under the camera
over a piece of celluloid; or, again, (3) by having
a number of little stars cut out of paper and

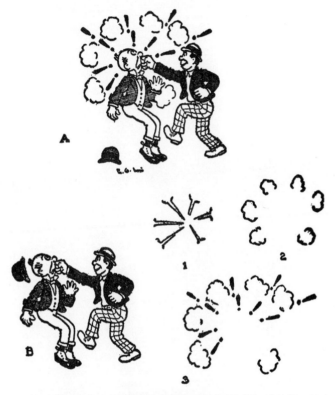

The simple elements, 1, 2, and 3, are used with sketch *B* to give the screen effect shown in *A*.

moved around and manipulated the same as other cut-out models.

One can see from all these particulars that making animated cartoons is not always a matter of

drawing, pure and simple. The animator would make very little progress if he were to refuse to take advantage of any proper expedients or tricks to accelerate his work.

The animator, as well as the comic graphic artist, makes use of signs to elucidate the story.

MISCELLANEOUS MATTERS IN MAKING
ANIMATED SCREEN PICTURES

CHAPTER VIII

MISCELLANEOUS MATTERS IN MAKING ANIMATED SCREEN PICTURES

MANY of the striking ways of telling incidents of an animated cartoon put one in mind of the pictorial symbols of primitive man. An example is that of a vision appearing above the head of some one in doubt or in a revery. Then there is the miniature scene floating over a sleeper to tell that of which he is dreaming. These and other similar forms are supplementary ways of explaining incidents in a screen story. They are also used in the regular photographic film; but they are specifically typical of the animated cartoon.

They are amusing additions to a film that are certain to please whether used to apprise the audience of what is going on in the character's mind, or to explain the dream of a sleeper as he lies abed.

There are several modes of creating any of

these effects. The usual way would be that of having the quiescent part, say it is a sleeper, limned on the celluloid; and the details of the moving part, say the vision, on three or five sheets of paper.

Perhaps the humorist-artist wishes to make his picture a little bit more telling by indicating, with appropriate onomatopœic consonants, the sound of snoring. These additions can be drawn

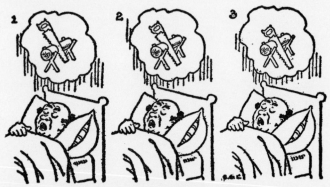

SYMBOLIC ANIMATION OF SNORING.

To effect this, the sleeper would be drawn on celluloid and the pictures in the clouds on separate sheets of paper.

while the photography is taking place on a blank celluloid sheet superimposed over all the drawings in a way explained in a preceding chapter.

Symbols of musical notation and sound-imi-

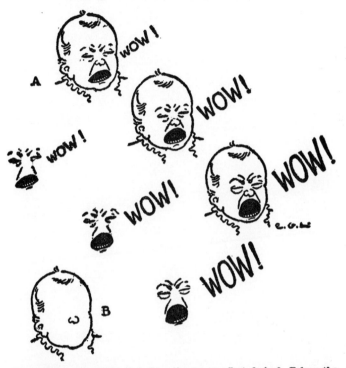

Series of drawings marked *A* show the screen effect desired. *Below:* the elements representing it that are used with the simple component—on celluloid—marked *B*.

tating words are often introduced into a screen picture. They can be made to dance in rhythm, or at haphazard, by drawing them in series of three or so, on celluloid sheets. These would be placed, one at a time, in their order over the general scene and repeated as long as desired.

The employment of balloons—they have been alluded to before—is a frequent one in comic screen work. They are the mouthpieces containing the dialogue of the characters. Their outline, more or less balloon-shaped, hovers over the heads of the speakers. The lines defining the balloons can come into the scene gradually in a lively way, and the dialogue itself can come in word by word. This latter scheme itself suggests talking.

When the first animated cartoons were produced and an effect with balloons was intended, the artist thought that he was doing well enough if he showed the lettering and merely had the person supposed to be speaking standing motionless. But now an artist who cares enough for his craft to put as much business into the scenes as possible will show the lips moving and the arms gesticulating at the same time that the lettering appears.

There are innumerable things that the artist must think of while he is photographing his drawings, and one of the weighty ones is to have the lettering for any particular dialogue, or explanation, held long enough on the screen for it to be

read. Every studio has its own special rule as to
the number of separate frames of a film to allow
for a word. The only way to arrive at any con-
clusion as to how much film to take for any
sentence in a balloon, or on a title, is to have
some one read it and then time this reading. In

A "CLOSE-UP."

this way the artist will be able to tell how much
to give any particular wording. He will be able,
too, after a while, to formulate his own rule with
regard to the matter.

A favorite method of telling something, or to
hint as to that which is to follow, is to have a

character discovered reading a newspaper upon which the item explaining the matter shows in an exaggerated type. The design is usually enclosed within a circle with the outside space a solid black. There is no special reason for using this particular encircling design. It is a way often used. Technically it is a good plan to employ this telescopic mat, as it may be called, as its forcible contrast of solid black margin breaks the monotony of the general uniform photographic tone of the rest of the film.

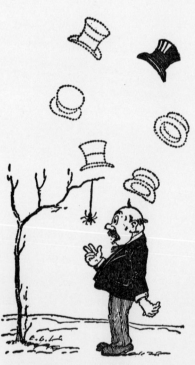

To vivify this on the screen, little "model" hats are used during the photography.

An amusing occurrence sometimes brought into a story is that of having a man's hat fly from his head into the air and come down upon

his head again. Of course, the practical way of putting this on a length of film would be that of having a little cut-out dummy. The artist, however, takes the trouble of making several dummies of the hat drawn in different views. A single dummy would show but a mere mechanical turning, but by using several in different views, he gets a very good similitude of actuality in the wind twirling the hat around in a lively way. A little point to help the humor of the situation is that of having the hat hesitate, as it were, and give an extra spin immediately before it lands upon the head.

It isn't always necessary for an artist to make a cycle or a series of drawings for a movement. For instance, he is showing a rather large face on the screen and it is intended that the eyes move. This could be effected by drawings, but there is a much simpler way. The places for the eyes on the main drawing are left blank and holes cut out the size of these blank spaces. On a narrow piece of paper at the proper distance, two eyes are drawn. This paper, with the eyes, is slipped underneath the one with the drawing that has the eye spaces cut out. Now the ma-

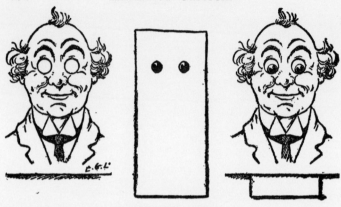

"CUT–OUT" EYES.

nipulation of this paper, holding the eyes while in
position under the face, is easy. The various posi-
tions in which the eyes are placed, it is under-
stood, will be photographed by the stop-motion
method.

The true artist, in keeping with his talent for
creative work, will be disposed to devise helpful
contrivances or expedients to lighten irksome
and monotonous details arising in this art. And
in addition to the possession of this talent, and
that of good draftsmanship, he must be quick
in deciding on the best means of economizing
labor, so that he can spend more time where thor-
ough drawing is needed. He must, in short, in

any particular case, put in as much work as it requires and no more. By experience he will learn to know where to slight—"slight" isn't exactly the word, but it will do—the drawing.

With respect to this latter point, suppose there is some arm movement, with the arm swinging as it does in a hurried walk. Hands, it is certain, are difficult details to draw, and if they are carefully rendered in all of the positions it would take a long time to draw the entire series. But the experienced animator has learned that at times he can, for some of the positions, every other one perhaps, make quickly lined marks indicative of hands. These quickly made lines, however, must be drawn in a way that will help the action. Exactly how to make them and to what extent to "slight" them is learned only by long experience.

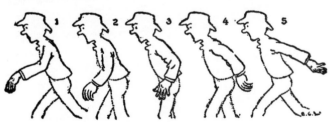

For some quick actions, "in-between" drawings can be slighted as shown in numbers 2 and 4.

Often there is a question as to the number of drawings necessary for a movement. If a hand, for example, is to be moved from the side of the thigh to the head and then to touch the brim of the hat, one single position half-way between the

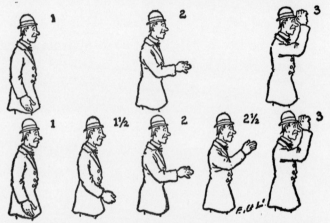

ILLUSTRATING THE NUMBER OF DRAWINGS REQUIRED FOR A MOVEMENT.

Above: for a quick movement.
Below: for a slower movement.

two extreme ones may do for some swift action in a humorous cartoon, but if it is for a slower action it should have at least three positions between the extremes.

But it doesn't worry the skilled animator very much whether he makes three, five, or even more

drawings between the extreme positions of any gesture or action. Nevertheless, while the artist is making these arm movements he must put thought into the work. There is, for instance, a certain matter with respect to drawing the relative axes of the segments of a limb that requires reflective attention. To be precise, suppose the action is to represent an arm moving from below and pointing with the index-finger skyward. Now, in any directly following phases of the movement the same degree of flexure at the articulations must not be present in the drawings. The whole arm as it hangs by the side, before the action begins, is nearly straight, with very little bending at either elbow or wrist. In moving it upward, it is not to be traced with this same relative straightness and same degree of joint angularity in all the positions. It would move then on the screen with the ungracefulness of an automaton.

Instead, the several drawings should have the joints—elbow and wrist—at different degrees of flexure. Especially is this difference to vary from one drawing to a succeeding one, with the angle at the joint, just a little more, or just a little less. The whole matter can be best com-

prehended if the artist, before depicting this action, try it himself. Then he would see that if he moves the arm as if it were a rigid thing, only

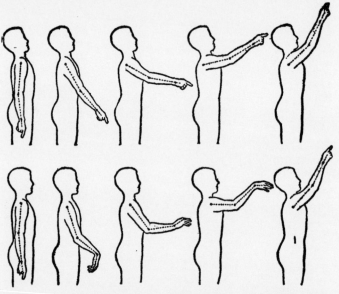

ILLUSTRATING A POINT IN ANIMATING A MOVING LIMB.

Above: moving automaton-like with no bending at the joints.
Below: moving with various degrees of flexion at the joints.

hinged at the shoulder, the movement would be false and not characteristic of a living organism. The natural way is an unconstrained, easy bending movement. The animator in his drawings slightly emphasizes this manner of moving.

An artist shows his aptness for character delineation in the way in which he draws the views of a face for turning it from side to side. A graphic caricaturist of limited scope has a proneness for adhering to a few stencil patterns, in the matter of pose, for his characters. Front face, profile, and occasionally a three-quarter view make up his catalogue of facial picturing. The animator uses this delineatory trilogy, too, in the ordinary turning of the head from side to side. But he must be skilled, besides that of portraying a face in these views, in drawing it in any view. And a skill that is still more needed is that of being able to keep the portraiture of a character throughout any series of drawings.

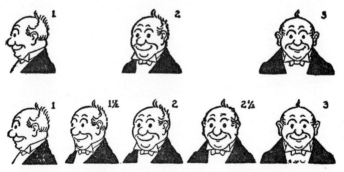

In turning the head from profile to full face, one drawing between the extremes is sufficient for a quick movement. But when it is desired that the action be "smoother" two more drawings are required.

To keep the features the same throughout a number of drawings it is found advantageous to spend a little more time in the preliminary planning when creating the original sketch for the character. The idea is not so much to make a face that is easy to draw as to give it certain distinguishing lineaments that are recognizable in the varying positions needed in animating it.

Besides, when originating a face for frequent repetition in a cartoon, seeking one that can be drawn quickly and easily represented in any view facilitates the work of the tracers.

A little trick of comic graphic artists is that of making the features of a face in small circles, or somewhat roundish curves. This sort of thing is not conducive to good character drawing. The animator also uses these forms—round eyes, circle-like nose, and a circular twist in other parts of the features. Now in his case, this can be forgiven, perhaps, when one considers the difficulties of his art; for these particular forms are, as we shall try to explain immediately below, easy to copy and trace. As in caligraphy, unfixed and diverse in its qualities and peculiarities, so with every individual in pen drawing, certain traits

occur in the strokes. In pen - and - ink draw-
ing the more individual and distinctive the style,
the harder it will be to copy or counterfeit it.
But if the markings approach the geometric,
definite and precise, then they are easily copied
and imitated. This is why the little circles and
similar curved markings are so frequently used
in animated cartoons. There is nothing ambig-
uous in the lineaments of a face made with saucer-
like eyes, and a nose like a circle. Its peculiarities
are quickly noticed, easily remembered, and traced
with facility.

As has been explained, an artist rarely finishes
an entire set of drawings for a film without help,
but has a staff of helpers. It can be well under-
stood, then, that an essential to success is that
the members of this staff keep the same quality
of line in all the drawings. One of the difficulties
in a staff of helpers is that of keeping a uniform-
ity of portraiture in the characters. And because
the circular lineaments are easy to trace that is
the reason why they are chosen to form the basis
for the details of a face.

There is a tendency in every one, even on the
part of the author of the original model, to depart

Easily drawn circular forms and curves make for speed in animated cartoon work.

from the first-planned type of face. The approved
way of avoiding this is to have a set of sketches
of the characters drawn on special sheets of paper
that are to be used by all the workers to trace
from. In a studio with numerous workers, all
rushing to finish a five-hundred-foot reel in every
week, it is the custom to have plates engraved
from the original sketches and a number of copies
printed, so that all may have a set. With these

printed copies it will then be merely a matter of having a steady hand and an ability to trace accurately from the copy on to a fresh sheet of paper placed over the illuminated glass of the drawing-board.

No doubt, as it has been referred to so many times, it is clearly understood now what an important part transparent celluloid plays in this art. It is employed not only to save the labor of reproducing a number of times the details of a scene, but also to help keep these details coincident, or uniform. In a face, there is a certainty that its lineaments will be the same if it is drawn but once on celluloid; but if it is copied each time on a long string of successive sheets of paper, there is a likelihood that it will vary and so give the lines on the screen an effect of wiggling about.

There are many little matters of technic and rendering that arise in this art. For example, in making certain parts of a figure, say a coat, in solid black, it has been found best, instead of making it an absolute silhouette, to indicate by the thinnest of white lines the contours of the details. A sleeve, for instance, should be outlined with such a white line. This seems to be

a lot of trouble for so little, but, judged by the result on the screen, has been shown to be worth while.

At this point we can touch upon the question of what is meant by "animation." An artist with little experience may make a series of movement phases for an action, but when the drawings are tested it is found that they do not animate; that is, give in synthesis the illusion of easy motion. It may be a matter of incorrect drawing, perhaps, or he may have the drawings nearly correct, but he has failed to make use of certain little tricks, or, shall we say, failed to observe certain dexterous points in the technic of the art?

We will cite one little trick—humoring the vision, if one may put it this way: have a spot, or patch, of black repeated relatively in the same position throughout the series of a movement. An example is that of having the boots of a figure of a solid black. The eye catching the two black spots as they alternately go back and forth is deluded with respect to the forcibleness of the animation even if the walking action is not as correctly drawn as it should be. An added effect is given to this illusory ruse if a tiny

high light is left on the toe of each black boot.

The final test for drawings for animation is, it stands to reason, the result on the screen. One may, though, approximately find out whether or not any sequence of drawings animate by flapping them in a sort of way akin to the book-form kineograph novelty noted in a preceding chapter. Two immediately following drawings can be tested this way: with one hand they are held near one corner pressed against the drawing-board, then with the other hand the top drawing is moved rapidly up and down. In this way the two drawings are synthesized somewhat, and if the action is delineated correctly there will be some notion of the appearance on the screen.

This little experiment crudely demonstrates the phenomenon of after-images and the operation typifies a simple synthesizing apparatus.

A significant addition to a scene, if it is suited to the story and consistent with the general plan, is to have some foreground detail in front of the moving figure, or figures. This sometimes consists of a rock, a clump of foliage, or a tree trunk. The contrast of the inertness in these details gives

an added force to the animating that takes place back of their mass.

This feature of a picture is drawn on celluloid that is placed on top of the rest of the set having to do with the particular animation. It is pos-

Foreground details of a pictorial composition help the animator in several ways. Their inertness, for one thing, affords a contrast to the moving figure.

sible, though, for an artist, if he is dexterous, to fasten this inert foreground to the under-side of the glass in the frame which is pressed down over the drawings during the photography. The foreground feature, of course, is cut out in silhouette and fastened with an adhesive like rubber cement.

This cement is an article of great usefulness in a photographic studio; especially for temporary use over drawings, as it can be easily rubbed off afterward by the friction of the finger-tips.

Radically opposite in method to the scheme described above, in which an inert object helps the animation, is the panorama. In this screen illusion the figure, which is thought of as moving, occupies the same position; while the landscape, normally quiet, is in motion.

Certainly we have all experienced the sensation, when seated in a railway-train waiting for it to go, of suddenly imagining that it has started; when, in fact, it has not budged. This simply has happened: while occupied with thoughts not pertaining to our surroundings—perhaps reading—we casually caught sight of a moving train on an adjacent track, and as we were in the state of expectancy of at any moment being on the move, we immediately thought that our anticipation had been fulfilled. Even if, in a moment or two, we realize that our senses have deceived us, it is hard to shake off the first-formed delusion of being in motion.

Now the screen panorama is a similar delusion.

We see near the centre of the screen a figure going through the motions of progression, but we know perfectly well that he is in the same place all the time. And we know that the landscape is drawn on a band of paper that is pushed along back of the figure. All our knowing does not help us. In spite of it the little figure spectrally advances and the landscape deceptively passes by as we know it does (visionally) when we ourselves are running very fast.

The manner in which a panorama is produced is this: the landscape is drawn on a long strip of paper; this is to be moved little by little and photographed at each place to which it has been moved. The figure that is to walk, or run, is drawn in the different phases of action on sheets of celluloid. These are placed in their order over the landscape during the photography. The separate drawings of the actions of the figure were drawn so that the bodies remained relatively in the same place, but the limbs, or heads, varied in attitudes. The planning of the action in a figure for a panorama is proceeded with in the same way as that for producing a regular walk or run. One special care in the work, however,

MAKING AN ANIMATED CARTOON PANORAMA.

The figure is depicted in a series of movement phases drawn on separate sheets of celluloid. These are used continuously, one at a time, and in their proper order during the photography. The landscape, drawn on a strip of paper, moves along under the celluloid little by little in the direction of the arrow.

193

is this: the limbs as they are sketched in their appropriate attitudes in the several drawings must not have identical outlines. That is, explaining it in another way, if all of the set are placed together over the illuminated tracing glass, no two drawings should correspond with respect to the positions of the limbs. The bodies in the drawings should exactly concur in position, but if some attention is given to the rise and fall of the trunk, as in a typical walk, the screen illusion will be very much better. Slightly shifting it up and down on a vertical would effect this.

The band of paper with the landscape is moved in the direction opposite to that in which the figure is supposed to go.

The photographer has many things to think of while he is putting this panorama effect on a film. He must move the landscape strip; sometimes as little as one-sixteenth of an inch at a time; put a celluloid sheet with one of the phases of the action in place, get it in its proper order, and then turn the camera gearing to make the exposure. In some special cases he will have another matter to think of; namely, a second panorama strip to move, and at a different speed.

This is when he wishes to give a little better representation of verisimilitude than that produced by the single panorama strip.

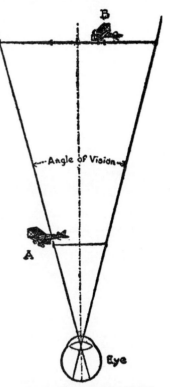

Far-off moving objects, as we know, appear to go slower than those that are close to us. We are aware of this in looking at a distant airplane high up in the sky that we know is going very fast but seems as though it is going very slowly. And at night an illuminated railway-train in the valley below us, when we are on an elevation, seems to creep along like a snail.

ILLUSTRATING THE APPARENT SLOWNESS OF A DISTANT MOVING OBJECT COMPARED TO ONE PASSING CLOSE TO THE EYE.

To bring it to pass that a panorama have the effect of near objects going faster than those that are distant, it is necessary to have two strips of

panorama details. One strip will represent the foreground, which is to be moved much quicker, one-eighth of an inch, or so. A second strip will answer for the distance, which is moved, about one-sixteenth of an inch, or even less. If the foreground strip is moved at rather wide intervals, the effect on the screen will be a little like that which we see from the window of a railway-coach when telegraph-poles and near objects seem to fly by.

The panorama strip for the foreground is designed with simple elements so that it can be cut out in silhouette and laid over the other one. With reference to the quality of the details of a scene on a panorama; although it is usual to fill up the whole length with items of interest, there must be observed some degree of simplicity. Perhaps it might be best to say that there should be a subordination in the details, even if they are numerous, and then have some striking feature or object occurring every once in a while, to catch the eye and so help the movement.

Objects, too, automobiles and other vehicles, are combined with these panoramas. This brings us to the consideration of the matter of animat-

Some distinguishing mark on a wheel is needed to give it the screen illusion of turning.

ing wheels, or making them turn in the screen illusion.

A wheel true and accurately adjusted and going rapidly gives—with the exception of a blurring of spokes, if there are any—very little evidence of rotation. It is only when it turns unsteadily, or when there is some distinguishing mark found on or near the rim, that we see plainly that the wheel turns. Sometimes it is a stain, a spot on the tire, a temporary repair, or a piece of paper that has caught in the spokes that indicates a turning of the wheel. Further amplification is needless, as a glance at the vehicles, as they pass in the roadway, will make clear. So the animator, when he wishes to show a wheel turning, simply copies actuality by drawing a wheel with some such feature as noted above. A mere black spot on a wheel near the circumference is some-

times sufficient. It is usual to have the wheels drawn on thin cardboard and cut out and fastened in their proper places so that they can be turned. They are turned a little at a time and photographed after each turn.

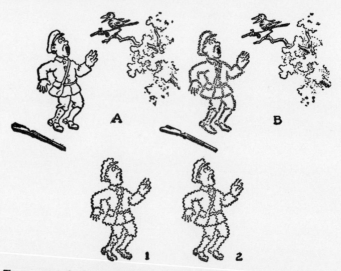

To represent the hunter in sketch *A* suddenly trembling with fear as in sketch *B*, two drawings, 1 and 2, with varying wavy lines are used alternately during the photography.

PHOTOGRAPHY AND OTHER TECHNICAL MATTERS

CHAPTER IX

PHOTOGRAPHY AND OTHER TECHNICAL MATTERS

RESPECTING adaptability and results, the same motion-picture camera that is used in the field, or the studio, can be used to make films for animated cartoons. In making cartoons, however, two particulars at variance with the usual procedure first must be noted: (1) The camera is pointed downward and not horizontally, as is ordinarily the case, and (2) with each turn of the camera handle only one frame—one-sixteenth of a foot of film—is photographed, and not eight, as is commonly the case.

The camera in making animated cartoons is held, pointing downward, by a firmly built framework. The artist, having decided on the dimension of the field for his drawings, determines the height approximately of the camera above the table top, where the drawings are placed. Naturally it will be high enough so that when he works

at the table while disposing the drawings, adjusting the dummies, or in some cases making drawings, his head will not come in contact with the front of the lens. The particular distance between the lens and the table top is dependent upon the kind of lens in the camera. It is a common practice to equip a camera with a two-inch (fifty-millimetre) lens. It is possible to use a lens of this focus for cartoons.

There is no special type of structure for supporting the camera above the board upon which the drawings are placed for photography. An artist contemplating embarking upon this line of work, and intending to carry on the whole process from the beginning to the time when he hands the exposed film to the laboratory for development, will have a chance to put any inventive ability that he may have into practice in designing a framework for the purpose. In building such a structure these things must be thought of: (1) The structure must be firmly built so that the likelihood of the camera being jarred is lessened; (2) the distance between the camera and board to be ascertained, approximately at first; (3) an arrangement for fixing the camera in a

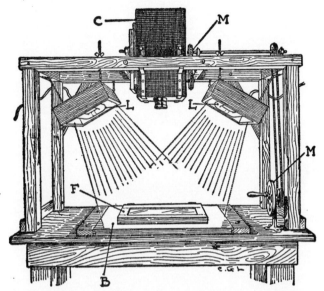

TYPICAL ARRANGEMENT OF CAMERA AND LIGHTS TO
PHOTOGRAPH DRAWINGS FOR ANIMATED CARTOONS.

C. Camera. *L*. Lights. *M*. Mechanism to turn camera shutter. *F*.
Hinged frame with glass to press down on the drawings. *B*. Board
holding the registering pegs.

grooved sliding section so that its exact height
can be adjusted when the field and focus are
definitely fixed or there is to be any later read-
justment. The camera, for instance, may get
jarred and put out of focus, or get set obliquely
with respect to the lines defining the field.

Some animators have mounted their camera
so that the same framework can be used for a

small field as well as a larger one. This necessitates, each time that the size of field is changed, a troublesome setting of the camera in order again. It is wisdom to keep to one size of field for all work, so that when the camera is once in position it need not be changed.

The frame that holds the glass, and which is hinged to the board where the drawings are placed, and the registering pegs have already been described. It is an excellent plan to have this board with the above-named adjuncts separate but screwed down upon the table top. By having it this way it is possible to have another means of getting the camera and the field lines adjusted. Then if the outline of the field on the board and those defining the field in the camera do not fit each other exactly, the board can be unscrewed, shifted until it is right, and fastened again.

In any film where there is a preponderance of straight lines—horizontal ones, especially—it is a serious fault to have the slightest obliquity. It will be emphasized on the screen. The outlines of the little rectangular area, where the pictures are taken in the camera, must coincide with the outlines of the field on the board. When the

field is fixed and permanently marked with ink lines, it is a good plan to draw a smaller rectangle, one-half inch all around, within the outer one. The idea of this is to have a limiting area within which all important matters of the drawing are kept.

If the animator has had any experience with the ordinary still camera, the practical knowledge gained then will help him in the matter of focussing, or regulating the diaphragm of the lens, so that all the details of the picture are sharply defined. This comes next, or rather in conjunction with the determining of the field and the permanent fixing of the camera. In a still camera—that is to say, an ordinary portrait or view apparatus—the focussing is on a ground glass, while in a cinematographic instrument it is usual to place a piece of celluloid with a grained surface somewhat like ground glass into the place where the film passes. The picture is focussed on this celluloid. Some, however, find a piece of blank film answers the purpose.

To the above consideration of setting up the camera and ascertaining the correctness of the field and the sharpness of the image, the worker

wise in perception will, before beginning any important work, make a test. This is merely a matter of photographing a drawing, or two, on a short length of film, taking it out of the camera, and developing it. Here, again, any knowledge of photographic processes previously learned will be found useful.

There are in all metropolitan centres film laboratories to which the animator can send his exposed films to be developed and printed. But for a test before beginning the work it is prudent and expeditious to keep a supply of chemicals on hand, and then, in a few minutes, it will be possible to tell how matters stand in any particular that is in doubt.

The next step, after the camera has been fixed in place, is to construct a mechanism by which it can be turned conveniently by the photographer, as he is seated below at the board where the drawings are placed. This is contrived by a system of sprocket-wheels and chain-belts coming from the camera and carried down to the side of the table top, where it ends in a wheel with a turning handle. For the average individual this would not be a difficult construction to put up; but it

would be an altogether different problem if the animator wished to equip his camera with an electric motor to turn the camera mechanism. In this case he would have many things to consider, getting the particular type of motor, for instance, that will operate with the continual turning on and off of the power. Here certainly the best course is to have an expert install the motor and fix the intermediary mechanism connecting it with the camera-working parts.

Electric motors to drive camera mechanisms are in general use among those who make titles for moving-picture films. For this particular branch of the industry they are an indispensable adjunct.

It would seem to the spectator in the theatre, unfamiliar with the technic of cinematography, that when he sees a title held on the screen for any lengthy period, the practical way of effecting this would be to have a single picture of this title kept stationary during the period. But this is not the way the matter is worked out. A title in a screen story is given a certain length of film, with every frame in this length containing the same words. The particular length—foot-

PART OF A LENGTH OF FILM FOR A TITLE.

For every second that the wording is viewed on the screen, sixteen of these frames pass through the projector.

age—allowed for a title depends upon the amount of its reading-matter. Some titles are very long. One such, requiring, say, fifteen feet, makes it necessary to turn the camera handle two hundred and forty times, if the operation is by hand. A very monotonous job. So title studios attach a motor and appropriate mechanism to a camera, and with it, too, an automatic counter. Then in photographing a title it is a simple matter of starting the mechanically driven shutter, watching the figures on the

counter dial, and when the required exposures have been registered, pulling the lever that stops the mechanism. Where a camera, however, is used for animated drawings exclusively, a motor is not absolutely necessary.

An automatic counter would be a very useful addition to a camera in making dissolves. One form of these fantasies is that in which the screen is perfectly black at first and then a small spot of light appears, which grows larger by degrees, to reveal at the full opening the scene or subject of the film. This is produced by a vignetter, or iris dissolve. A vignetter is a device, fixed generally in front of a lens, that consists of a number of crescent-shaped segments of thin metal pivoted on a circumference. When these segments move in unison toward the centre, they gradually decrease the aperture in the lens tube. But when the movement is in a contrary direction, they cause the aperture to open by degrees. Those who have used an ordinary snap-shot camera no doubt are familiar with a similar device—the iris diaphragm, or lens stop. But in the diaphragm the segments do not completely close, and there is always a tiny opening left in the

centre. The iris dissolve, or vignetter, is made to close completely.

The way by which pictures are "faded on" is to start with the vignetter closed and then open it while the camera handle is turned to take the picture. To "fade off" a picture, the process is simply reversed; *i. e.*, gradually closing the vignetter while the last part of the picture is being taken.

The most frequent application that an animated cartoon artist makes of a vignetter is making cross dissolves, or causing one picture to blend into another. Imagine now that the idea to be expressed, through the medium of one of these cross dissolves, is that of a character standing in an attitude of reflection and supposed to be thinking of how he would look in a complete suit of armor. There will be two drawings: one with the figure in ordinary dress, and the other with him clad in the armor. First the picture with ordinary dress is photographed. During this operation the vignetter is closed by degrees. When it is closed, the film that was just photographed upon is wound back again into the magazine. Now, as we know, during this procedure the

light, which was getting weaker and weaker, proportionately lessened its effect on the sensitized emulsion of the film, so that its picture-forming property was not all used up. There is still a certain proportion of photographic potency left for the next exposure. The next step is to replace the first drawing with the one showing the character in armor.

We left the vignetter completely closed, and the same length of film that had just passed back

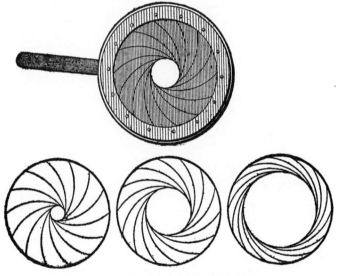

VIGNETTER, OR IRIS DISSOLVE.
Below: Three stages during the movement of the pivoted segments.

of the lens has been wound back into the magazine and is ready to cross the exposure field again and be photographed upon the second time. Now the vignetter is gradually opened, the new picture is being taken and blended with the image of the first picture.

These two procedures in their method of operating and their effects compensate one another. The gradual closing of the vignetter has its reciprocal part in the gradual opening; the lessening of the light strength is reciprocal to the increase of the light strength; then the fading of definiteness in one picture is made up by the gradually increasing clearness in the other.

In trick work of this kind a mechanical counter would be very useful in measuring the length of film as it is turned into the magazine and then out again. It is understood, of course, that our particular counter also counts backward. And, again, with reference to cameras: an animator when he selects his camera should be certain that he gets one with which it is possible to turn the camera backward for making these dissolves and any other trick work involving like manipulation.

Immediately above we gave certain reasons

for the making of tests on a small piece of film before photographing. Another matter for which tests should be made is the question of illumination. It is important that the field should be evenly illuminated. All this is an affair of adjusting the lights; that is, getting them one on each side of the camera in their proper positions with reference to the lens opening and the distance away from the drawing-board.

DIAGRAM TO EXPLAIN THE DISTRIBUTION OF LIGHT IN A CROSS DISSOLVE.

A. When the vignetter is gradually closed during the taking of the first picture. (The film having been wound back is ready to be photographed upon again for the second part of the procedure.) *B.* While the vignetter is gradually opened during the taking of the second picture. *C.* The percentages of light in the two exposures combined and giving the complete exposure time.

The mercury vapor-lamp which, as has been mentioned, is in general use for cartoon films, has besides its illuminating qualities another great merit. It is this: it does not emit heat rays. When it is remembered that an artist sometimes spends hours at a stretch photographing his numerous drawings for a cartoon film, and that all this time his head is but a few inches from the lights, this absence of heat is a desirable feature.

The manner of going about the photography, which is the next stage of the work, has been touched upon in another part of the book.

There are many more minute particulars in the making of an animated film to be considered. Take, for instance, the technical questions respecting the preparation of the drawings. In the process where most of the drawings are made on paper, the paper should be a fair quality of white linen ledger paper—but not too thick, as transparency is a thing to think of, and it is preferable, too, that there be no water-mark. The design of a water-mark would be a disturbing element in tracing from one drawing to another. Ordinary black drawing ink is used for the line work,

but when a large area is to be solid black, it has been found best to employ one of the black varnish stains that are mixed with turpentine. In spite of the turpentine medium it is possible to apply it to paper. These black stains are an intense black and do not lose their strength when viewed through the celluloid sheets.

It is not usual to obliterate a mistake in drawing with white pigment, as it is an uncertain quantity in photography. Whether or not it will come out as a patch of gray, or photograph correctly as white, is difficult to judge beforehand. It is best to take out ink lines that are not wanted with a sharp-bladed penknife and then smooth the surface of the paper with an ink eraser (of rubber).

In drawing over the smooth surface of the celluloid a preliminary cleaning with weak ammonia water will make the ink flow evenly. It is of course understood that the celluloid sheets can be used again after any particular film is finished. Ink or pigment can very easily be washed off with water.

In drawing on celluloid with a pen it is well to select one that will not scratch the surface. Scratches will hold, in their shallow depths, enough

ink or pigment to break the evenness of a uniform background. They will come out as spots on the film. A well-worn pen, one that has been "broken in," as the pen draftsmen say, is the best.

The scheme of employing celluloid sheets to hold simple ink drawings, which scheme is in common usage in the art, has been adapted to the purpose of holding intricate drawings in distemper pigment. Before drawing any series of movements on celluloid it is the usual plan to work out all the scenes and actions on paper first and then trace them, from these drawings, to the surface of the celluloid.

When the drawings for a cartoon have been photographed, the magazine into which the exposed film has been wound is taken out of the camera. Then, in the dark room, the film is taken out of this magazine and put into a regulation tin can and sent to the laboratory. And so as to make it quite certain that the lid will not slip off and spoil the whole reel, it is sealed around the edge with a piece of adhesive tape.

After the film has been developed, the next step in the process is that of printing the posi-

tive. This as well as the remaining technical matters is attended to by the laboratory. Titles, to be sure, could have been made at the same time that the animated pictures were taken; but it is found advisable to have titles made by a

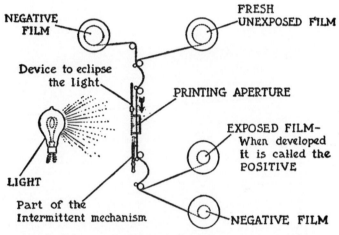

ILLUSTRATING THE OPERATION OF ONE TYPE OF MOTION-PICTURE PRINTER.

studio that does this work exclusively and then have them joined to the film in their proper order.

With respect to this joining, or splicing, this is also looked after for the animator at the film laboratory. But as it is not difficult to do, the animator—impatient to have his film completed,

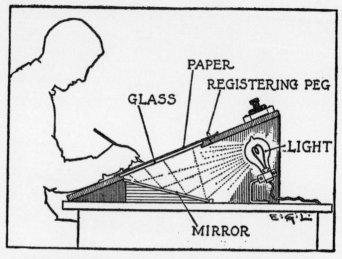

ANOTHER PLAN FOR AN ANIMATOR'S DRAWING BOARD.

Reflecting the light with a mirror does away with the direct glare of the electric lamp.

and not caring to wait until the laboratory finish it—will try his hand at it, no doubt.

He needs for this a little device to hold the two ends of the film together in their proper relationship while he spreads on the overlapping section a little film cement. This is a firm adhesive. The emulsion on the film where the cement is spread must be removed by a little moistening.

When the positive is entirely finished, with main title and subtitles, it is ready for screen examination. Then only will the artist be able to see, as a finality, his skill as an animator, his expertness as a technical worker, his cleverness as a humorist, and the extent of his adroitness in plot construction.

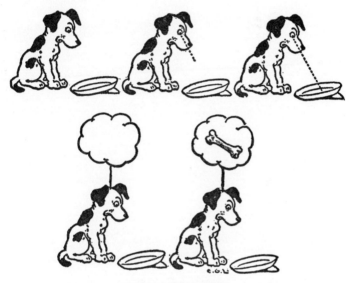

CANINE THOUGHTS.

In giving screen life to the above, the dog and dish would be drawn but once on celluloid and the other parts separately drawn for each phase of the movement.

ON HUMOROUS EFFECTS AND ON PLOTS

CHAPTER X

ON HUMOROUS EFFECTS AND ON PLOTS

THE purpose of the animated cartoon being to amuse, the experienced animator makes it his aim to get, as the saying goes in the trade, a laugh in every foot of film. The animated cartoon is allied in its kind to an extravagant farce or a lively comedy of the spoken stage.

Although strongly limned character and that there be something moving all the time seem to be the two important ingredients of a film of this type, it is not to be forgotten that plot is an essential in the work.

Naturally, a scenario, or skeletonized plan of the story, is written out first. The full details of the action and business, from the beginning to the very end, are not worked out as they are in a manuscript for a stage play. It is simply that some sort of a framework, on which to build the story, is first required.

In the early days of the art a film with a string

of incidents only, but with plenty of movement in the animated figures, would find a ready market and an appreciative audience. At the present time not only must the pictorial properties be well rendered imageries of nature but the story

PLENTY OF MOVEMENT IS DEMANDED IN SCREEN PICTURES.

must be artistic in form. This signifies that the idea of plot, and all its attendant concomitants, should be present. The usual requirements of a dramatic story are now sought for in an animated cartoon. The plot must be the orderly establishment of parts leading up to some main point, or the working to a climax and a subsequent untangling of it all.

If the artist does write the first sketch of the play himself, he at least will elaborate it and add various bits of dramatic business. This is all

very well if he understands and knows what he is about, but if, on the other hand, he has not the dramatic idea, his additions are quite likely to confuse the story.

Whether a film is for the purpose of amusement or to educate, the plan should show that the attainment of something is being striven for. In an educational film this is brought about by an adherence to pedagogical principles. If it is a comic story, due regard must be paid to dramatic construction.

It is obvious that if a humorous scenario has but two characters this will simplify the telling, and the idea of their antagonisms, obstacles, and embarrassing difficulties are easily told. The clash and the struggle between the two can be expressed in many simple ways, the story carried on, curiosity stimulated, and an expectant feeling engendered as to what will happen. The final episode is apt to be some calamitous fall with the whole picture area perhaps filled with a graphic representation of an explosion, to be followed by an after-climax, when the smoke has cleared away, of the victim rubbing his head.

To be sure, an animated cartoon needs a good

many more incidents than one calamitous occurrence. It is indispensable, for the sake of an uninterrupted animation, that it should have a succession of distressing mishaps, growing in violence. This idea of a cumulative chain of actions, increasing in force and resultant misfortune, is peculiarly adapted to animated drawings.

The animator, if he is a good draftsman, can manage his little picture people much easier than the theatrical manager does the members of his company. A great danger, nevertheless, is that the animator, with this facility of doing whatever he pleases with his characters, may overdo the matter. He must be careful that he does not create too much business for his actors, and so retard the sequence of those episodes proper to the plot.

The very best type of animated cartoon tells the story from the very first incidents and throughout its whole continuance to the crisis, and the ending by pantomimic acting only. This means that there is no dialogue lettered on the drawings themselves. Symbolical signs, like exclamation-marks, sound-suggesting letters, or the like, are naturally proper and happy additions to draw-

ings; but as little dialogue as possible should be used in drawings. They break the continuity of the animation, for one thing. Although it is true that balloons with their wording make an easy way for the animator to have the automatic counter register "footage" (a consideration appealing to the business sense of the artist), it is

THE PLAINT OF INANIMATE THINGS CAN BE RENDERED EFFECTIVELY ON THE SCREEN.

only when there is a good jest brought out that lettering on the drawings themselves can be forgiven.

In the early period of the development of animated comic drawings, not even subtitles were interspersed throughout a film. The entire story was told by pantomime. Nowadays it is becoming the fashion to use subtitles, and have them to introduce incidentals, mark a change of scene, or bring in a witty remark. Wording brought

into a cartoon film this way is often felicitous and technically legitimate. But dialogue, as has been stated, should be kept out of the drawings themselves, not only for the sake of artistic form, but for commercial reasons. (Films intended for exportation to countries where English is not spoken are much more valuable if they are without lettering in the pictorial parts. With all wording on separate titles, it is very easy to change them and have them joined to the film proper.)

The above statement with its frank allusion to a matter of business seems to be getting away from our subject; but it is not, as it calls to our attention the principal quality of a comic screen drawing—namely, pantomime—and it emphasizes, too, the universality of pantomime. An animated cartoon clever in gesturing is understood by all races.

It is to be remembered that pantomime is a matter of interpretation, both on the stage by an actor and by the artist when he essays to represent it pictorially. If it were an actual copying of nature, it only would be as interesting as a normal photograph; and that is not very interesting. As in all interpretative arts there is a

slight betrayal of the mechanical means, or processes, so in pantomime there is a suggestion of the mechanistic. Let us recall the rhythmical and toy-like movements of the actors whom we have seen playing in some whimsical dumb show.

How often do the clowns pretend in their foolery that they are automatons, or that they can move only by mechanistic motions. They find need, too, in their ludicrous acting, for mechanical properties—slap sticks, absurd objects, or toys.

It is very certain that there are some forms of motion productive of laughter that do not imitate actions natural to the human organism, but seem to acquire their power of risibility from their resemblance to mechanical motion. This is on the order of the notion that Bergson has elaborated upon in his treatise in explanation of the comic. He states, in substance, as one law of the ludicrous, that the human body appears laughable when its movements give a similitude of a machine in operation. There is no question of the correctness of this view as a matter of mere exterior observation. Rather it seems to us that machine-like movements in organic bodies amuse

us because of the rhythmic, orderly, or periodic occurrences of these movements in themselves, and not to any matter of comparison.

In a boisterous low comedy it is always incumbent upon the victim of a blow to reel around like a top before he falls. It never fails to bring laughter. An effect like this is easy to produce in animated cartoons. There is no need to consider physiological impossibilities of the human organism, the artist can make his characters spin as much as he pleases.

In a screen picture two boys will be seen fighting; at first they will parry a few blows, then suddenly begin to whirl around so that nothing is visible but a confused mass and an occasional detail like an arm or leg. It will be exactly like a revolving pinwheel. This is made on the film by having a drawing representing the boys as clinched and turning it around as if it were a pinwheel.

In a panorama screen effect it seems to be sufficiently realistic, for laughter purposes, to have the legs and arms of the individual in a hurry give a blurred impression, in some degree, like that of the spokes of a rapidly turning wheel.

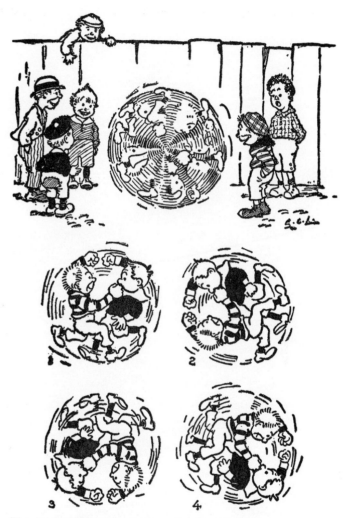

The pinwheel effect of the two boys that have come to blows is produced by turning around to four different positions a drawing representing the boys fighting.

It is an indisputable fact that the human mind finds fascination in any movement resembling a rotary one. Witness the interest that a novel mechanism or an automatic toy creates in a shop-window. Such interest is still further stimulated if there is an added item of anything of the human, or something definite accomplished in the operations.

We require, it seems, if we are really alive, not occasional, but constant, stimuli of some sort. When we become weary of toil—which in itself is often an unwelcome and imposed form of stimulus—we seek stimuli in recreation. Or if we haven't energy enough for the self-stimulation of sports, or the like activity, we look for it outside of ourselves.

Perhaps it is music, exciting us metronomically; or a play where our emotions are agitated—rhythmically or in dissonance; maybe it is a circus or the music-hall, where color and sound vibrations stimulate us. Everywhere it will be some form of measured time, movement, or rotation, whether the theme be comic or serious.

Idlers will stop to gaze at a machine in motion where there is building going on, or they will stop

to peer into the windows of a busy factory. There is something in all this that shows that the human mind craves the periodicity of stimulation.

Perhaps one of the reasons why those crudely executed white on black animated cartoons—alluded to in a preceding chapter—are so laugh-provoking is that they represent the characters performing their antics more or less mechanically. A windmill effect, a twirling, a spinning, and a merry-go-round movement are of striking import in animated cartoons. They never fail to cause laughter when depicted in some such fashion or other.

Sometimes in a pursuit in a comic picture there is an introduction of a chase around a house or around a tree. The gyration about the house is particularly productive of laughter. The slight interruption while the figure passes back of the house gives occasion for the necessary pause in this comic business.

The author recalls a film of real people and scenes that exemplified the potency of a mechanical turning and the value of a pause for laugh-provoking purposes. The scene represented a tiny bungalow that was blown from its founda-

tion by the force of the storm and made to re-
volve as if it were pivoted in the centre. The
droll character of the play saved himself from
being blown away by clinging to one corner of
the porch. The laughter of the audience although
continuous came in waves of different strength.
The twirling house itself caused laughter, but it
increased when the ludicrous figure clinging to
the porch came into view, and it decreased when
he disappeared while he was being twirled around
the far side of the house.

Possibly one of the reasons why this perform-
ance was so successful was because this move-
ment allowed for the physiological necessity of a
rest on the part of the spectators. The emotional
excitement would have been fatiguing to the
breaking point had the incitement to laughter
been continuous. The humorous proceeding op-
erated so that any individual member of the audi-
ence was not compelled to shake or be agitated
by laughter all the time, but could slacken up
and rest rhythmically.

The need of a rhythmic slowing-up, or pause,
to allow for a respite for the emotions and the
convulsed physical organism is well illustrated in

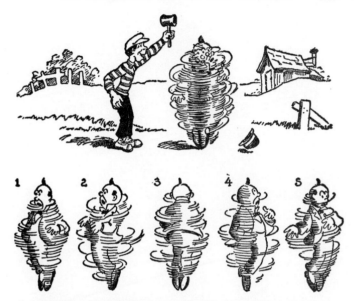

A cycle of drawings, like those above, used in turn and repeated for a time will give the screen illusion of a man spinning like a top.

the following incident often introduced into animated scenes. A little figure is observed running up hill and down dale. The manner of his performance is like this: he runs up the first hill and disappears; there is a moment or so when the scene is empty and during which he is supposed to be running down the far side of the hill. Soon he is discovered running up the second hill, at the top of which he again disappears for a time to

A blurred impression like that of the spokes of a turning wheel is regarded as funny in comic picturing.

run down its far side. In another moment he is scrambling up the next hill and down the other side again. This continues until he is lost as a tiny black spot near the horizon.

This disjointed hill-climbing causes hilarious laughter and, as in the case cited above, comes in waves. The rise and fall of the laughter waves can be distinguished as the little figure runs up the hills and down the valleys.

A pause is a necessary element in any continued comic situation. It is, in fact, proper to any series intended to arouse the emotion of laughter. And in some respects a pause corresponds to the negative moment of flexion — adverting our

thoughts for a moment to physical activity — while the outburst of laughter corresponds to the positivity of extension.

A bit of striking animation is that of having a continuous stream of individuals pouring out of a building, or a procession of funny animals coming out of a receptacle from which we did not expect such a parade. These episodes of movement do resemble a parade—a species of regularly recurring stimulation.

The psychological questions in regard to these effects is related certainly to the matter of the delight of the human mind in a stirring up by

FROM "THE 'BAB' BALLADS."

repetition. Undoubtedly the same liking or pleasure in these little bits of screen animation bear a resemblance to the delight experienced in watching a parade. What is there in a spectacle of this

sort that tickles our senses? Is it the regularness of the step-keeping, the hypnotic music of the band, or the show of varied uniforms? Perhaps the principles of unity and variety—two essentials of any art work—enter into the matter. The variety in the uniforms of the different sections

Pictures of this sort can be presented on the screen more vividly than in this simple graphic sketch.

satisfies the eye, and the unity of the marching pleases the mind.

Keeping step is an artificial recurrence of movement. It pleases, of course, but when this motion is rendered strongly mechanistic it takes on immediately an element of the comic. In some of the little figures drolly drawn by Bab (W. S. Gilbert, of "Pinafore" and "Mikado" fame), this is

HATS.

well expressed. A little picture of his, for instance, shows three tiny men stepping out like mechanically operated toys.

One of the most primitive of practical jokes is that of throwing a stone at a hat on some one's head. And its most aggravated form as a joke is that in which the hat is of a stovepipe pattern. In a humorous stage play, merely to show an individual with a stone in his hand while a sprucely

dressed one wearing a high hat is passing is motive enough to cause laughter. The graphic artist copies this situation by representing a stone in the air nearing the hat. Action lines, as they are called, indicate that the missile is flying through the air. In both of these cases—in reality and in

Radiating "dent" lines give emphasis to this bludgeon blow.

the picture—mere anticipation is enough to awaken the risibilities. The animator, of course, can gratify both the spectator's joy of anticipation and the mischievous delight of seeing the consummation of the action.

Many professional entertainers have built their reputation on some dramatic business with hats. Either they wear some odd head-gear or else it

will be in their manner of wearing a hat or a trick
in doffing it. If a hat is too small, it is sure to
create laughter; and if too large, it is a certainty
that there will be mocking hilarity. And even
if it is of the right size, it need only to be perched
on the head at an angle to be considered ludicrous.

The spirited screen actors, too, of the animator's
pencil are shown going through all sorts of strange
doings with their hats.

A chase around some object is a never-failing laugh-provoking incident
in an animated cartoon.

ANIMATED EDUCATIONAL FILMS AND THE FUTURE

CHAPTER XI

ANIMATED EDUCATIONAL FILMS AND THE FUTURE

NEARLY everything in our book so far, in accord with its title, has had reference to the making of comic screen drawings. They gratify a proper human longing and they strike a responsive chord in the consciousness. Now there is another kind of appeal, in the matter of satisfying a human need, to which animated screen drawings can be put. It is that touched upon in the introductory chapter; namely, animated films of educational subjects. By educational films would be meant, if the strict definition of the term is intended, only those that are instructional. It is to be remarked, however, that enlightened opinion now includes in the category of educational subjects any theme, or story for children, even if a slight touch of the humorous or diverting is to be found in it.

The kind of stories, with the latter thought par-

ticularly in mind, especially fitted for the screen
are those of Lewis Carroll. His "Alice in Won-
derland" is a good example of the type of fanciful
tale on the order of which animated cartoons could
be made for children.

And Sir John Tenniel's interpretations of the
characters seem to have been created especially

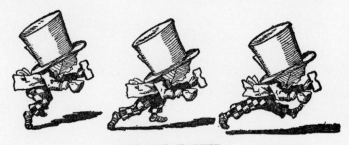

THE MAD HATTER.

for translation to the animated screen. The Mad
Hatter, with his huge beaver (signalizing again
the hat as inspiring the comic), would make an
admirable figure to pace across the screen

An artist desiring to be the author of an ani-
mated story built on the model of Carroll's classics
would need a gleeful imagination and a turn for
the fantastic. And he would require, besides,
if he hoped to draw characters on a par with

Tenniel's depictions, more than the ordinary quali-
fications of a screen draftsman.

As in the rough-and-tumble antics of the rustic
clown little refinement is either prevalent or ex-
pected, so in the ordinary comic animated car-
toon exquisiteness of drawing is neither found
nor ordinarily looked for. But in a story with
fineness of wit, and told artistically, it is obliga-
tory that its interpretation be of a corresponding
quality. It is necessary, in other words, that
the artist be good at figure work and especially
skilful in drawing difficult actions and perspec-
tive walks. As remarked before, when the latter
subject was considered, this requires dexterity
in picturing figures in foreshortened views. And
to become expert in this particular means study.
For examples of foreshortened figures to contem-
plate, the student of animation can find no better
ones than those in the frescos of Michael Angelo.
Especially valuable are the decorations of the
Sistine Chapel in Rome. Photographs or copies,
no doubt, of these wonderful art works can
be found in the print-rooms of public libraries
or in any collection of engravings of a picture-
gallery.

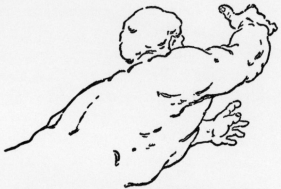

DETAIL OF A FRESCO BY MICHAEL ANGELO.

It is an entertaining speculation as to whether or not Michael Angelo, being a man of many artistic activities, would have tried his hand at animating drawings, had the art been in existence in his time.

In our own day, patterns for emulation in the matter of depicting action and the delineation of character are found in the drawings of Mr. A. B. Frost. Witness his achievements in these respects in his book "Stuff and Nonsense." Then, too, Mr. Frost's appreciation of the comic spirit is particularly noteworthy. His graphic work could with every success be set forth on the animated screen.

The old-fashioned peep-show has long since

passed its way, and in its place has come the cine-
matographic exhibition. Children consider it a
commonplace occurrence in their lives to be taken
to the "movies." Very soon they will imbibe
knowledge as well as receive entertainment through

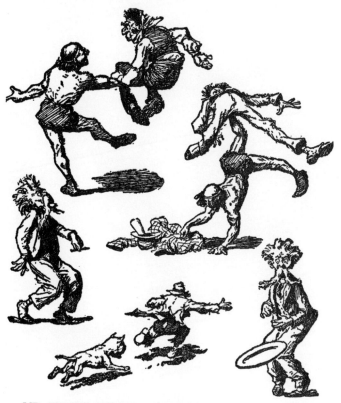

MR. FROST'S SPIRITED DELINEATION OF FIGURES IN
ACTION.

the medium of the films. There are many in-
structional themes that could be elucidated in
the school by animated drawings.

Educational, travel, and scenic films are fre-

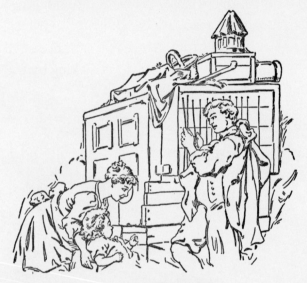

THE PEEP–SHOW.

Detail of a composition of a French eighteenth-century tapestry designed
by Boucher.

quently presented in motion-picture theatres,
but the possibilities in these subjects have not
been exhausted.

Some of the first investigators who looked into
the problems connected with photographic analy-

sis and pictorial synthesis to produce the appear-
ance of movement had ideas of applying the
results of their labors to practical purposes. M. G.
Demeny, in Paris, to cite an instance, invented
an instrument by which deaf-mutes could learn
to speak and to read lip movements. His in-
strument consisted of an optical contrivance that
gave the representation of a person speaking by the
turning of a glass disk upon
which there was placed a
series of photographs of a
person speaking. The pic-
tures were arranged in a
cycle which, when the disk
was made to rotate, pro-
duced a continuous effect
of the action.

DEMENY'S PHONOSCOPE.
Modified from a picture in
La Nature, 1892.

One form of this appa-
ratus, or photophone, was
made to be turned by
hand, and the combined picture or illusion viewed
through a lens by one person at a time. Another
type was constructed so that the synthesized pic-
ture of the speaking face could be thrown on a
screen.

There is a natural curiosity in nearly every one to want to know about methods in art. And the interest is general in watching a craftsman create an object of art, or an artist bring into graphic being some imagery of his brain. It would not be out of place for these reasons, as well as a matter of instruction, to produce films showing art methods.

Especially for elementary pupils would it be a desirable thing to show the way of making simple free-hand drawings. Then, instead of an instructor repeating the process—sometimes with indifferent interest or enthusiasm—it can be arranged that some one skilled in drawing, and when he is feeling at his best, go through the procedure under the motion-picture camera. The result could be multiplied a number of times and shown in many classrooms with an evenness of performance not possible when some one does it day in and day out.

Methods and principles of the more advanced branches of art instruction—pictorial composition, for instance, could be taught, too.

As one example, we will suppose that the purpose is to show what good pictorial composition

is. First an indifferent picture, poorly arranged, is shown; the various components appear on the screen exactly as they would in making a picture on canvas or paper; then little things pointed out that are lacking in artistic merit, or an explanation given of any detail that is not quite clear. (For this purpose a drawing of a pointer is made on cardboard and cut out in silhouette. It is moved around precisely as if it were a real pointer.) After showing the faulty construction the various components can be moved again, but into places to form the well-composed picture.

Methods of designing in the crafts could be demonstrated by animated drawings; and they could also be employed to explain visually the story or history of design. Ornament can be shown as it evolves from its natural form, to the first rudimentary basic type; then it passes into the best classical style, after which it becomes, as in all art evolution, the merely decorative. And it can be shown, as is usually the case in the history of an ornamental form, terminating in a debased and meaningless figure or scroll. All these screen pictures could be managed so that the pic-

tures go through their mutations before the eyes as if they were living things.

Presuming that in the acquiring of knowledge all brains function in a similar way, what could be better as a means of instruction than a film of some educational subject?

In any special study or theme in physics, for instance, an entire course could be planned for an animated film. Some of the divisions of the theme could be actual photographs of the experimental apparatus in operation. But other matters would need to be moving diagrams, or progressively changing charts. Explanations on the titles and other wording, previously thought out with due regard to their educational value, would be combined with the film.

Could there be anything more interesting than screen drawings of machinery in operation? To draw the successive pictures required for work of this character would present no great difficulties to any one trained in mechanical drafting. It would be a great improvement on the diagrams and mechanical plans with their complicated markings to see the work of the draftsman projected on the screen and giving the appearance

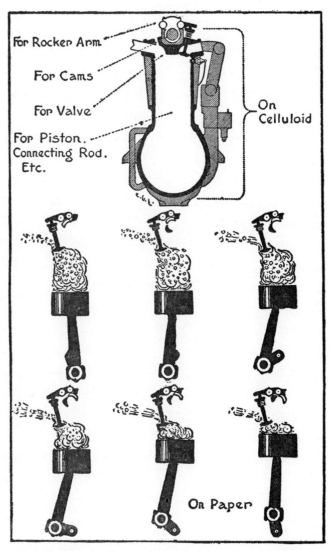

For Rocker Arm

For Cams

For Valve

For Piston.
Connecting Rod.
Etc.

On
Celluloid

On Paper

A FEW OF THE DRAWINGS USED IN THE MAKING OF A FILM
TO SHOW A GASOLENE-ENGINE IN OPERATION.

of motion. With vivid object-lessons of this kind, the eye can comprehend in a few moments that which it would take lengthy paragraphs to make clear.

On this subject of animating machinery, it is an interesting fact to note that as early as 1860, Desvignes, who invented one form of the zoo-trope, is recorded as having made a series of pictures for his optical instrument that showed a steam-engine in motion.

The teaching of history could be made still more interesting than it is by series of changing maps. Such maps would show, as their outlines changed, the growth or modification of a country as affected by events of history. Historical battles could be illustrated with the usual reference marks and symbols. But they would not be still; instead, they would move about to illustrate the progress of the battle. This form of animated maps frequently has been used in connection with pictorial-news reels.

Physiology and anatomy are two studies that need good pictorial exposition in the classroom. Scientific moving pictures of the actual subjects are in many cases available and their photography

is feasible. But for some details that cannot be taken with the camera, animated diagrams would have to be substituted. To suggest a very good theme in physiology, we may mention that of the circulation of the blood. Only a few particulars of this could be photographed. Most of the story of the blood circulation would have to be told by animated diagrams.

There would be at first, perhaps, a sectional view of the heart showing the auricles, and ventricles with the valves and their reciprocal action. The flow of the vital fluid, to be sure, would be indicated very clearly as it passes through the cavities. A striking animation of this film would be that of the blood flow in its course through the body. This would be represented by a schematic diagram like those usually set forth in the books. It would have an added interest if the fluid were colored—the arterial blood red and the venous blood blue. (This is the usual way, when printed in colors, in which they are distinguished in text-books.) A film like this, it can be understood, must be planned well—a scenario practically would be written for it.

The manner in which the muscles move the

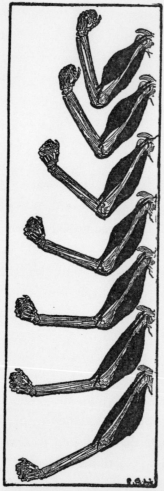

bony frame of the body can be strikingly demonstrated by animated diagrams. Take as a simple case the bending of the arm. The two antagonist muscles of the front and the back of the upper arm can be made to show as swelling and lengthening, alternately, as they flex and extend the forearm.

A similar animation of the skeleton would be that of the bony levers in the human frame. And as a comparison, actual mechanical levers of all three orders could be made

THE ACTION OF THE MUSCLES ON THE FRAME COULD BE
SHOWN ON THE SCREEN.

A series of drawings like this would be the first thing to prepare for
making the film.

to operate in connection with the levers in the skeleton.

It would be possible, to some extent, to put the "Origin of Species" on the screen with the help of animated diagrams. For the vertebrates, a section of the film could represent a schematic evolutionary tree. On it, the lower forms of backbone life, such as amphibians and fishes, would be placed on an offshoot near the lowest part of the main trunk. Odd creatures like marsupials would branch off a little higher up, and still higher a larger branch of the tree would split into two minor branches for reptiles and birds, respectively.

The tree would show above a branching off into three important divisions for the ungulates, carnivores, and quadrumana. The story could be continued by separate delineations of the different branches and tell in further detail the development of the forms that belong to them.

The art of the animated cartoon and the educational screen drawing has as yet not been developed to its highest point. It needs, for one thing, color. Such films are only shown, at present, in monochrome or simple outlines. Of course

colored cartoons will come. Effecting the tinting by hand would be easy as a process, but very tedious and costly. A practical way of coloring the ordinary photographic film is now in use by tinting them with the aid of stencils. Both the stencil-cutting and the coloring are accomplished by the help of machinery.

At present there are color processes that produce very beautiful photographs on the screen; but they do not show, at least in those that so far have come under the observation of the author, all colors of nature. The craft is awaiting the inspired inventor who will produce motion-pictures in colors that will exhibit nature's full range of hues and shades. Then in comparison with Niepce's simple process, of about 1824, of fixing a lens-formed image upon a metal plate coated with bitumen, the photographic art will have attained to a marvellous degree of technical development.

A consummate color process should reproduce, too, an artist's work upon the canvas without losing any variations of hue that he has set forth. Then it will be possible to have animated paintings. One will go, when this wonder has been achieved, to an exhibition gallery to see art

works with the additional interest of movement as well as those of color and individual interpretation. And, too, our museums will have projecting rooms and fireproof libraries for keeping films.

It seems like fantastic dreaming to hold such notions; but many things that were once considered purely visionary—have now become commonplaces.